IMAGES
of America

ARIZONA
RANGERS

IMAGES
of America

ARIZONA
RANGERS

M. David DeSoucy
Foreword by Marshall Trimble

Arizona Historical Foundation

ARCADIA
PUBLISHING

Published by Arcadia Publishing
Charleston, South Carolina

Printed in the United States of America

Library of Congress Catalog Card Number: 2007934174

For all general information contact Arcadia Publishing at:
Telephone 843-853-2070
Fax 843-853-0044
E-mail sales@arcadiapublishing.com
For customer service and orders:
Toll-Free 1-888-313-2665

Visit us on the Internet at www.arcadiapublishing.com

This book is dedicated to all those men and women who, as Arizona Rangers, faithfully strive to live up to their oath and go forth into harm's way to protect and serve the public, especially to those Arizona Rangers who died in the line of duty protecting and serving the citizenry of both the Arizona Territory and the state of Arizona. They significantly contributed to establishing law and order during the territorial period and continue to keep the peace within the state.

Pvt. Carlos A. Tafolla, October 8, 1901
Sgt. Jefferson P. Kidder, April 5, 1908
Sgt. John W. Thomas, July 21, 1992

CONTENTS

ACKNOWLEDGMENTS

After contemplating the research requirements for this book, I contacted the state commander of the Arizona Rangers, Col. Sid Chandler, to inquire about the possibility of collaborating. He graciously responded and invited me to attend the Rangers' statewide meeting in Rio Rico. As a retired peace officer, I was welcomed and treated with professional respect, even if I was from California. Looking forward to interacting with these Arizona Rangers, I became most impressed with what I heard and observed. Ultimately they voted to support the proposed book project, as it was well received, endorsed, and supported by the Arizona Rangers organization. As the project developed, I traveled throughout Arizona meeting with most of the Ranger companies at their regularly scheduled training meetings, as well as social functions, and was treated with the utmost hospitality by these splendid folks. Without their input, this book would not have been possible. Thus, I thank you all and salute you for your commitment and dedication in serving the citizenry of Arizona.

I want to give special thanks to Col. Sid Chandler, Arizona Rangers historian Maj. Anita Korhonen, Arizona Rangers Museum archivist Lt. Carol Sullivan, and state law enforcement support coordinator Lt. David Bruce. Your assistance was especially helpful to this book.

I would also like to express my appreciation to Arcadia Publishing and editor Jared Jackson of the Arizona Historical Foundation for taking on this project. I am grateful to Arizona's official state historian, Marshall Trimble, for providing the foreword, along with some witty advice; and to author and historian Bill O'Neal for his insight and guidance. Lastly, special thanks go to my dear wife, Angelika, for enduring yet another project.

FOREWORD

Although America was changing rapidly with the dawning of the 20th century, most of the Arizona Territory was still tied to its wild and woolly past. Lack of effective law enforcement, bad roads, rough country, and a close proximity to the mostly unguarded 100 miles of the Mexican border made it the last refuge of outlaws and rustlers. Between 1897 and 1900, there were six train robberies on the Southern Pacific alone. Large, well-organized bands of rustlers openly defied the law, stealing cattle in broad daylight. Payrolls from the mines were being stolen frequently.

The territorial legislature finally gave in to political pressure from mining and cattle interests in March 1901 and passed a bill creating a company of Arizona Rangers. Modeled after the famous Texas Rangers, a company was raised consisting of 14 men—a captain, a sergeant, and a dozen enlisted men—all serving one-year enlistments. They were placed under direct command of the territorial governor. The number would later be increased to 26 men. They were stationed mostly along the Mexican border in southeastern Arizona because that was where most of the outlaws were operating. Using the old adage "It takes one to catch one," most of the Rangers were a rough-and-ready band of hard-riding men who would fight at the drop of a hat. At first, they operated clandestinely. Keeping his identity hidden, a Ranger would infiltrate a gang and then, when he had members caught in the act of rustling, pin on his badge and make the arrest. It took a man with the bark still on to be a Ranger. It was not long before the Rangers had the outlaws on the run.

The Rangers would become the darlings of the press, something that did not endear them to local law enforcement. Unfortunately the governor began to use them as strikebreakers, and their folk hero status among the populace was damaged.

The Rangers were so good at keeping law and order they pretty much put themselves out of a job. A budget-minded legislature and partisan politics, along with political pressure from other law enforcement groups, caused their termination in 1909. They had pretty much outlived their usefulness and, like buffalo, native warriors, false-front saloons, and gunfighters, faded from reality into the realm of romance as Arizonans began to look ahead to statehood and the 20th century.

—Marshall Trimble, Arizona State Historian and Honorary Arizona Ranger

INTRODUCTION

The title *Arizona Rangers* conjures up many different experiences and images for those familiar with the name. Some of our thoughts are based upon historical research and scholarly study, yet others are purely folklore and media representations of that heritage. The term *Ranger* is not unique to the Arizona experience and has been immortalized within the American psyche from the earliest of Colonial times. The vast majority of Ranger organizations in American history were established as militias to defend against the enemies of the era. As militias, they were viewed as military formations rather than law enforcement agencies. One of the better known of these early militias, which did eventually become a law enforcement agency, is the Texas Rangers. They trace their history back to 1823; however, they were not mentioned in the Texas legislature until 1874. Numerous other examples of militia organizations using the Rangers title can be found throughout the classic Old West era. Some militias made the transition to law enforcement agencies, but most others faded away.

The history of the Arizona Rangers falls into four distinct periods. The first period began in 1860 when Gov. Lewis S. Ownings of the newly established Provisional Territory of Arizona authorized the formation of a company of Rangers to protect the citizenry within the territory and thus be referred to as Arizona Rangers. As a militia company, its mission was battling hostile American Indians and in particular the Apaches. Capt. James H. Tevis commanded a force of largely former Texans who were spoiling for action. While organizing the Rangers, ominous rumors of a possible war loomed over the nation, with Arizona citizens and politicians alike tending to favor the cause of the South. When the Civil War began in 1861, the Provisional Territory of Arizona became the Arizona Territory, Confederate States of America. The Arizona Rangers were disbanded as they joined the forces of the Confederate army.

The second Arizona Rangers period started in 1882. The U.S. Congress had passed a bill on May 8, 1862, establishing the Territory of Arizona and thus reclaiming it as United States territory during the Civil War. After the war ended in 1865, numerous hardworking citizens and outlaws gravitated to the Arizona Territory to seek their fortunes. Over the course of the 1870s and early 1880s, these outlaws and other undesirables became quite a nuisance in Tombstone and along the border with Mexico. Gov. Frederick A. Tritle took office on March 28, 1882, and stated, "We will have law and order even in Tombstone," as he set out to form a company of Rangers to deal with the criminal elements. These Rangers were short-lived also, as federal funds were not made available to finance the company.

The third and fourth periods of the Arizona Rangers are the subject of this book: the territorial Arizona Rangers, 1901–1909; and the modern Arizona Rangers, 1957–2007. This work is not a concise or thorough rendering of their history, but rather a historical pictorial overview in this 50th anniversary year of the reestablishment of the Arizona Rangers.

—M. David DeSoucy

One

ARIZONA RANGERS
1901–1909

The Arizona Rangers were established as a result of a combination of cattle industry concerns over rustling and the continuing effort for statehood. A number of cities such as Phoenix, Tucson, and Prescott were well on their way to a 20th-century lifestyle of well-established communities with thriving businesses, churches, and schools, but the majority of the Arizona Territory remained unspoiled and wide open. This vast territory of more than 114,000 square miles, along with the Mexican border, offered up numerous opportunities to criminals and outlaws who scorned honest labor and progress. With progress and statehood in the balance, most Arizonans felt that the rule of law needed to be thoroughly established in the territory. The Arizona Rangers were established to meet the challenge with, according to one historian, "frontier justice in the 20th century."

Over the almost eight years of the Rangers' existence, 107 men passed through the ranks of the company. Of these, 44 (41 percent) hailed from Texas, with only 9 being native Arizonans. About a quarter of them had previously served as Texas Rangers, deputy sheriffs, and peace officers. Well over half had been cattlemen, cowboys, or stockmen. Several had previously served as soldiers during the Indian Wars and the Spanish-American War. They brought a diverse background of experience to combat lawlessness and bring law and order to the vast Arizona Territory.

Unfortunately, on October 8, 1901, the Rangers took their first casualty when Pvt. Carlos Tafolla was shot dead, along with posse man Bill Maxwell, while attempting to apprehend the Bill Smith gang. Private Tafolla had only enlisted about a month earlier. It would be noted time and again that Ranger work was seriously dangerous and not for the timid or weak of heart.

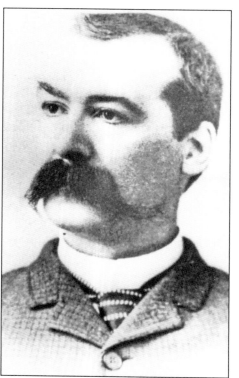

On March 21, 1901, the 21st Territorial Legislative Assembly established the Arizona Rangers. They were intended to primarily protect the cattle trade and address the problem of cattle rustling. Burton C. Mossman had substantial background and experience in the cattle business and previously served as the superintendent of the famous Aztec Land and Cattle Company, generally referred to as the "Hash Knife." After being approached, Mossman accepted the position of captain in the Arizona Rangers. Organized along the lines of the Texas Rangers, the group utilized military rank titles and was authorized 14 men. The monthly salaries were $120 for the captain, $75 for the sergeant, and $55 for the privates, plus stipends for expenses and feed. All Rangers had to provide their own horses and tack. Captain Mossman further directed that all Rangers were to possess or purchase Winchester Model 1895 rifles in the standard army-issue .30–.40 Krag caliber and revolvers of the "army size." As such, the Rangers "were armed with powerful Winchester repeating rifles and the reliable Colt .45 single action revolvers," according to Bill O'Neal's *The Arizona Rangers*. (Courtesy of Southwest Studies, Scottsdale Community College.)

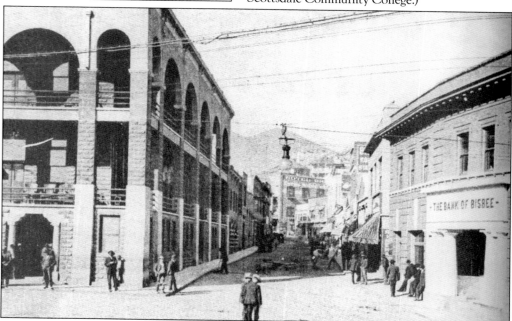

The copper mining town of Bisbee would serve as the location of the first Arizona Rangers headquarters. It was selected for its proximity to the Mexican border, as well as its criminal activity, guaranteeing that the Rangers' presence would be beneficial to the community. (Courtesy of Southwest Studies, Scottsdale Community College.)

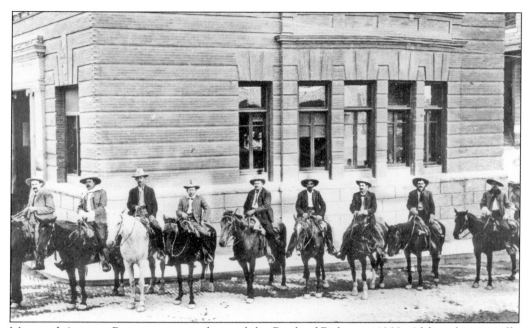

Mounted Arizona Rangers pose in front of the Bank of Bisbee in 1902. Although originally authorized 14 men, the Rangers rarely operated at full authorized strength. This would prove even more so after 1903, when they were authorized 26 men. (Courtesy of Brig. Gen. Wendell W. Fenn, U.S. Army, Ret.)

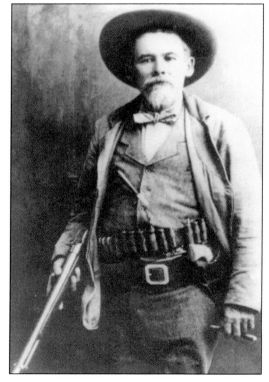

This c. 1890 photograph shows legendary Cochise County sheriff John H. Slaughter (1887–1890). Sheriff Slaughter owned the San Bernardino Ranch, which is still located on the Mexican border 18 miles east of Douglas. As both a cattle rancher and peace officer, he was an outspoken supporter of the Arizona Rangers from the beginning to the end. He understood the southern Arizona Territory and the type of lawmen it took to keep the peace and maintain law and order. He had served as a Confederate soldier and Texas Ranger, driven cattle, and participated in his fair share of scrapes. Slaughter held a Cochise County deputy sheriff's commission until his death in 1922. (Courtesy of Southwest Studies, Scottsdale Community College.)

11

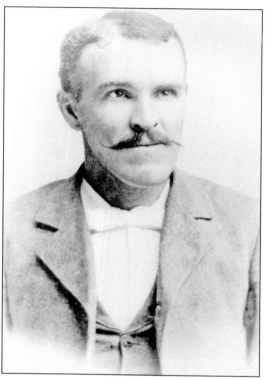

On January 1, 1902, Bisbee peace officer Dayton Graham accepted the position as the first sergeant of the Rangers from Captain Mossman. With only five days as a Ranger, Sergeant Graham led a posse that resulted in the arrest of three rustlers. A month later, on February 1, he resigned his Ranger commission to become the first Bisbee city marshal. Captain Mossman persuaded him to return as sergeant on April 1, but by March 31, he had resigned permanently. After becoming the constable of Douglas, he was wounded in a 1903 saloon gunfight that left another peace officer dead. According to Bill O'Neal's *The Arizona Rangers*, "A few days later," he gunned down the culprit and, some time later, shot and "wounded a Mexican who tried to resist arrest." Graham eventually found himself sentenced to fives years for murder. (Courtesy of Bisbee Mining and Historical Museum.)

William L. Stiles, pictured in this mug shot, figured into Captain Mossman's plan. Billy Stiles had previously served as a peace officer in the territory before becoming an outlaw. He was a known associate of Burt Alvord, another outlaw who had also been a peace officer, and was running with Augustine Chacon (also known as Peludo). In January 1902, Captain Mossman approached Billy Stiles, offering to put him on the Ranger payroll and to testify in his defense about some outstanding charges if Stiles would help him contact Burt Alvord and arrest Chacon, thus sharing the reward money. By April, Captain Mossman had determined he could go forward. With some letters from Judge William C. Barnes in Tucson, he set out to wrap up his complex plan. As he had done with Billy Stiles, Mossman told Alvord Burton he had papers from the judge that stated he would help in the form of amnesty if Burton surrendered and gave up Chacon. (Courtesy of Yuma Territorial Prison State Historic Park.)

Augustine Chacon (right, after his capture) was a notorious and ruthless *bandido* who resided in Sonora, Mexico. For many years, he had terrorized both sides of the border, especially targeting the Arizona side, where his name was known far and wide. He is believed to have been responsible for dozens of murders, about which he bragged, along with a long list of other felonies. He had been captured in 1895 after being wounded in a shoot-out with a posse led by Graham County sheriff Billy Birchfield. He was held in the Solomonville jail following his sentence to hang for the cold-blooded murders of Morenci storekeeper Paul Becker and Graham County Sheriff's Posse deputy Pablo Salcido. Nine days before his appointment with the hangman, he escaped from jail and fled to Mexico, picking up the alias of Peludo ("hairy," for his black beard). Several years later, in 1902, after having cleaned up most of the rustling, Capt. Burt Mossman was determined to bring him in. (Courtesy of Southwest Studies, Scottsdale Community College.)

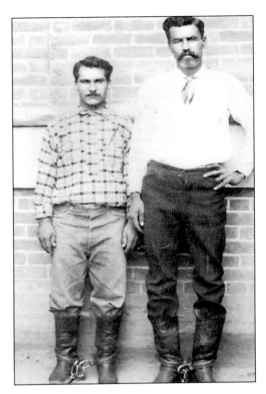

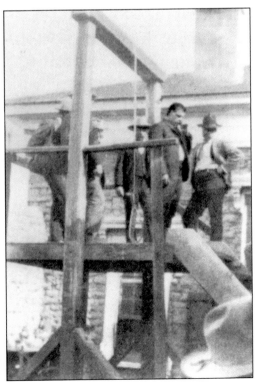

The ruse worked, with Captain Mossman arresting all parties and escorting them back to Arizona. Augustine Chacon finally met his executioner in Solomonville on November 23, 1902. (Courtesy of Southwest Studies, Scottsdale Community College.)

Capt. Thomas H. Rynning had served in the 8th U.S. Cavalry during the waning Apache Wars and again during the Spanish-American War in Cuba, as a lieutenant with the 1st Volunteer Cavalry Regiment (also known as the Rough Riders). He received his Arizona Rangers captain commission on August 29, 1902, from a former Rough Rider major, Gov. Alexander O. Brodie. A former Rough Rider colonel, Pres. Theodore Roosevelt had appointed Alexander Brodie as the Arizona Territorial governor that same year. (Courtesy of Arizona Rangers Museum and Archives.)

Pres. Theodore Roosevelt (fourth from left) visits Arizona's Grand Canyon in 1903. At far right is Gov. Alexander Brodie, who also served as a major in the Rough Riders. It is believed by many that former Rough Riders dominated the ranks of the Rangers, but in reality there were only seven who served under the three captains, and three of those had been sworn in by Captain Mossman. Other than Captain Rynning, only one former Rough Rider served more than a year, and only two were ever promoted beyond private. (Courtesy of Sharlot Hall Museum, Prescott.)

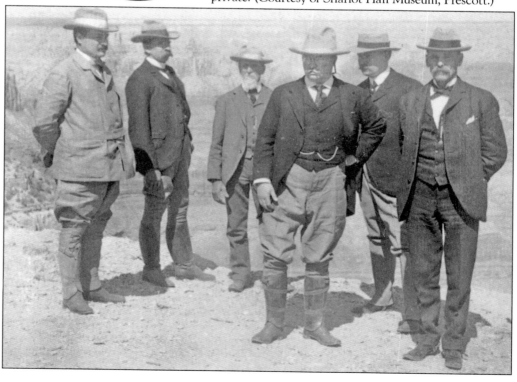

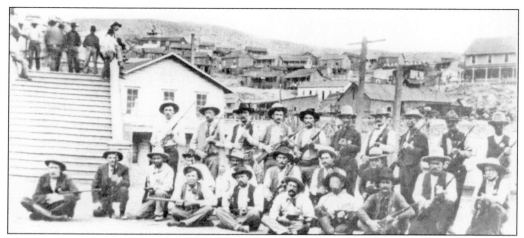

Rex Rice took this photograph, along with others in Morenci, on June 11, 1903. Pictured from left to right are the following: (first row) William Webb with an earlier model rifle, Chapo Beaty, David Warford, James Holmes, and Alex MacDonald; (second row) Capt. Tom Rynning, Lt. John Foster, Jack Campbell, William Allison, Fred Barefoot, Owen Wilson, Frank Wheeler, John Mullen, Oscar Felton, and Henry Gray; (third row) Billy Sparks, Bob Anderson, William Peterson, Bud Bassett, Tip Stanford, Tex Ferguson, Sam Henshaw, Charlie Rie, Arthur Hopkins, and James Bailey. (Courtesy of Arizona Rangers Museum and Archives.)

Act 64, passed by the 22nd Territorial Legislative Assembly on March 19, 1903, authorized the expansion of the Arizona Rangers to 26 men, to include "one captain, one lieutenant, four sergeants and not more than twenty privates." Monthly salaries were also increased to $175 for the captain, $130 for the lieutenant, $110 for sergeants, and $100 for privates. A provision allowed for silver, five-point, ball-tipped badges with "Arizona Rangers" engraved in blue to be issued to all. The captain's, lieutenant's, and sergeants' badges had ranks engraved, and the privates' badges were numbered. Badge No. 11 was last issued to Pvt. John McKittrick Redmond in 1908. (Courtesy of Arizona State Library, Archives, and Public Records, Archives Division, Phoenix, No. 98-9901.)

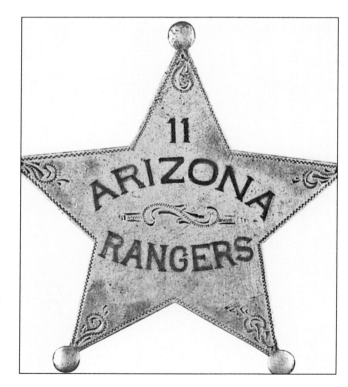

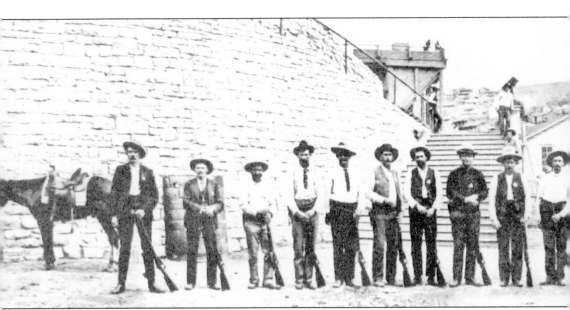

On June 11, 1903, the entire Ranger company (minus Jefferson P. Kidder) was in attendance at the Morenci mining strike as Rex Rice, who managed the on-site Phelps Dodge Mining Company's mercantile, took this widely known photograph. Between sources there is some minor conflict as to the exact name sequence, but the following is generally accepted. Shown from left to right, along with the highest rank attained and years of service, are Capt. H. Thomas Rynning (1902–1907), Lt. John Foster (1902–1907), Sgt. John E. "Jack" Campbell (1901–1903), Lt. William D. Allison (1903–1904), Pvt. Fred S. Barefoot (1901–1903), Pvt. Owen C. Wilson (1903), Sgt. Frank S. Wheeler (1902–1909), Pvt. John O. Mullen (1903), Pvt. Oscar Felton (1902–1905), Sgt. William "Timberline

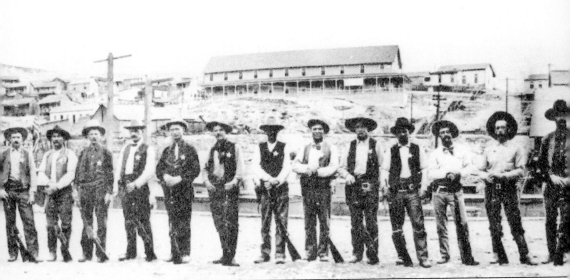

Bill" Sparks (1903–1909), Pvt. Robert M. Anderson (1902–1908), Pvt. William S. Peterson (1902–1905), Pvt. James H. "Bud" Bassett (1902–1905), Sgt. Tip Stanford (1903–1909), Pvt. William F. "Tex" Ferguson (1903–1904), Pvt. Samuel Henshaw (1903), Pvt. Charles Rie (1903–1904), Sgt. Arthur A. Hopkins (1903–1906), Pvt. James D. Bailey (1903–1905), Pvt. William W. Webb (1902–1903), Sgt. Henry S. Gray (1901–1905), Sgt. Clarence L. "Chapo" Beaty (1903–1907), Pvt. David E. Warford (1903), Sgt. James T. Holmes (1902–1909), and Sgt. Alex R. MacDonald (1903–1904). (Courtesy of Don Lunt, Greenlee County Historical Society.)

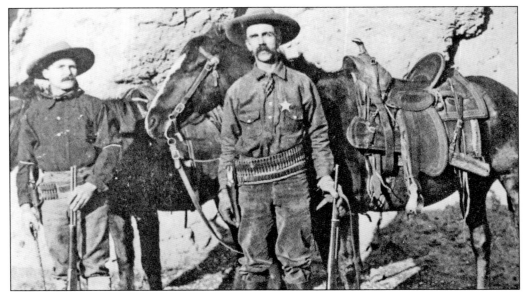

Deputy Sheriff Clark A. Farnsworth (left) and Pvt. William K. Foster, who was born in New York and enlisted at age 36, are seen in the field in 1903. (Courtesy of Southwest Studies, Scottsdale Community College.)

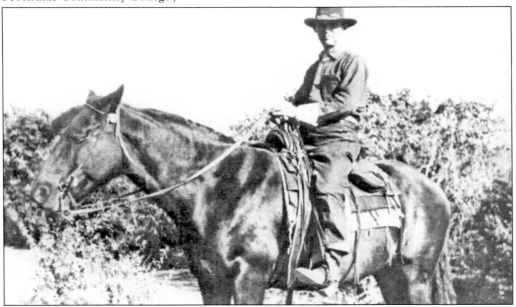

Pvt. James D. Bailey, born in Kentucky, enlisted at age 33. He served at Morenci during the 1903 mining strike and, in December of that year, was involved in a standoff with three rustlers near Flagstaff. Private Bailey had arrested one skinning a beef, and as he departed with his arrestee, the man's two rustling partners set up on the trail to confront the Ranger. Bailey used a quick ruse to distract the outlaws, rapidly dismounted, and got the drop on them with his Winchester. As a result, all three were taken to Flagstaff, where they were tried and convicted of grand larceny. In 1904, Bailey—along with Rangers Chapo Beaty and George W. Devilbiss—rode over 1,000 miles tracking rustlers north of Flagstaff. (Courtesy of Arizona Rangers Museum and Archives.)

Born in Texas and enlisted at age 36, Lt. John J. Brooks (1903–1905) was promoted to lieutenant in April 1904 and served well. He was involved in two shoot-outs and once planted Mexican coins in 13 "unlucky" calves so they could later be identified as stolen property. He was successful, as the coins were used for evidence and the rustler pled guilty. Although this photograph appears inverted, with Brooks's badge pinned on his right chest, close examination reveals that he inadvertently pinned it on the wrong side, possibly dressing in front of a mirror. (Courtesy of Arizona Rangers Museum and Archives.)

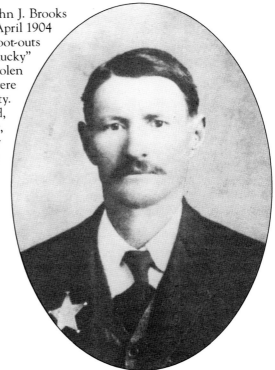

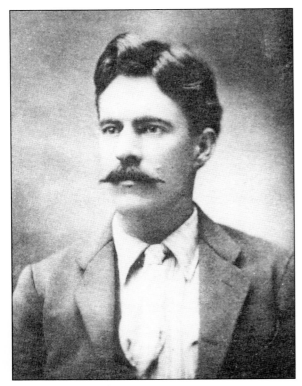

Harry C. Wheeler (1903–1909) was born in Florida and enlisted at age 26. Having previously served in the army, he brought a wealth of knowledge and experience to the Rangers. Wheeler, the only Ranger to be promoted through every rank, served as the last commanding officer. (Courtesy of Arizona Rangers Museum and Archives.)

Sgt. Harry C. Wheeler is pictured with his horse around 1903. Wheeler's reputation became legendary as he fought and shot his way up through the ranks to command the Arizona Rangers as the last captain. He was involved in a number of shooting scrapes, fatally shooting three outlaws, and was wounded at least once as a result of gunfire. (Courtesy of Arizona Rangers Museum and Archives.)

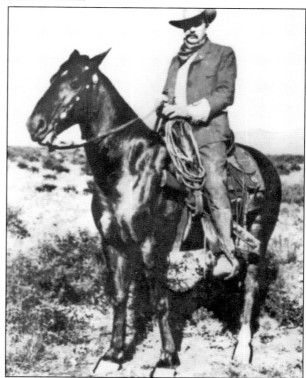

Capt. Thomas Rynning is pictured astride his sturdy mount. (Courtesy of Arizona Rangers Museum and Archives.)

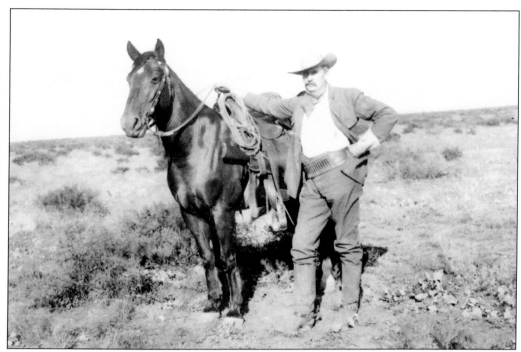

Shown in the field is Capt. Thomas Rynning with his horse. (Courtesy of Western History Department, Denver Public Library.)

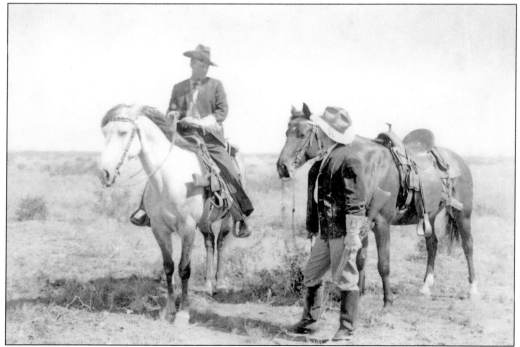

Sgt. Harry Wheeler speaks with a dismounted Ranger. (Courtesy of Western History Department, Denver Public Library.)

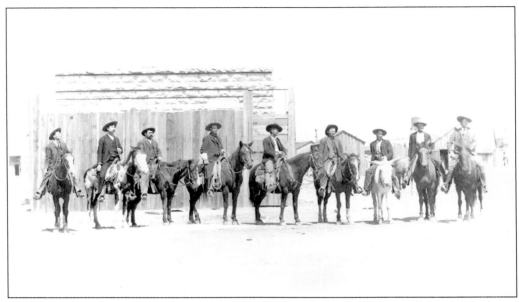

The 1903 Arizona Rangers posse included the following identified individuals: Pvt. Robert M. Anderson (second from left), Pvt. Chapo Beaty (third from left), Pvt. William W. Webb (fourth from right), Pvt. Jefferson P. Kidder (third from right), and Capt. Thomas Rynning (far right). (Courtesy of Arizona Rangers Museum and Archives.)

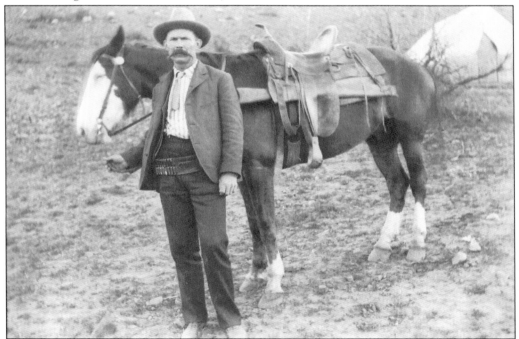

Pvt. William S. Peterson was born in Texas and enlisted at age 38. Serving at Morenci during the 1903 mining strike, he was assigned to Roosevelt, where this photograph was taken on March 31, 1905. (Courtesy of Frank P. Sieglitz Photographs, Arizona Collection, Arizona State University Libraries.)

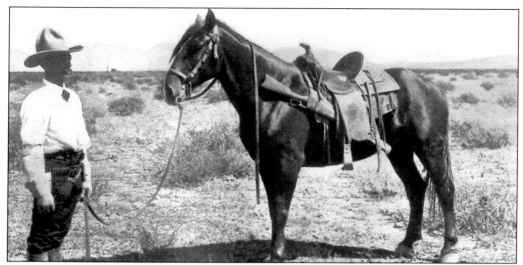

Sgt. James T. "Shorty" Holmes enlisted at age 30. He served at Morenci during the mining strike and was promoted to sergeant in 1904 but had reverted back to private by 1905. Holmes was involved in three shoot-outs during his seven years of service. On October 31, 1905, while on assignment in Roosevelt, he confronted a bootlegger who was "suspected of selling liquor to the Indians." The suspect attempted to "fight his way" through, which ultimately proved fatal. On February 18, 1906, Holmes was again involved in a gunfight with an "Apache outlaw." He came into some scrutiny for using excessive force on a double murder suspect. Holmes captured the suspect after beating him on the head with a frying pan and then tethered him around the neck and dragged him into town. The locals took notice and were not amused. The suspect "was fortunate he had not been shot," said Bill O'Neal in his book *The Arizona Rangers*. (Courtesy of Arizona State Library, Archives, and Public Records, Archives Division, Phoenix, No. 96-2387.)

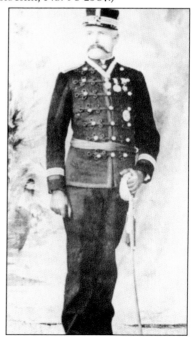

Col. Emilio Kosterlitzky commanded the Mexican Rurales, which were essentially the Mexican counterpart of the Arizona Rangers. Kosterlitzky was an interesting fellow: Russian by birth, as a midshipman he had deserted the navy while in a Mexican port of call. His desire was to be a cavalryman, and he saw his opportunity in Mexico. Kosterlitzky rose up through the ranks of the Mexican cavalry, joining the Rurales and eventually becoming the commander. He was respected on both sides of the border and frequently cooperated with the Arizona Rangers in capturing outlaws. As the Mexican Revolution went sour in 1914, he elected to immigrate to the United States, where he was attached to the U.S. Department of Justice during World War I. Kosterlitzky established a career in government service, retired, and died on March 2, 1928, at 75 years of age. He is buried in Los Angeles. (Courtesy of Southwest Studies, Scottsdale Community College.)

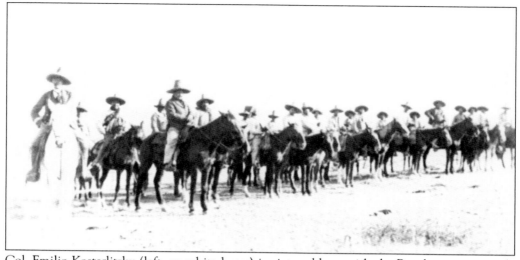

Col. Emilio Kosterlitzky (left, on white horse) is pictured here with the Rurales, an extremely effective and at times ruthless mounted law enforcement organization. (Courtesy of Arizona Rangers Museum and Archives.)

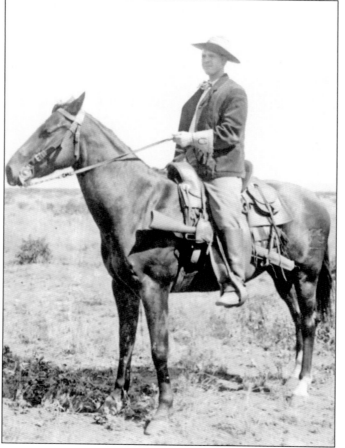

Sgt. Arthur A. Hopkins was born in Colorado and enlisted at the age of 26. He had previous service as a soldier when Captain Rynning recruited him primarily for the purpose of addressing administrative matters. Hopkins was eventually promoted to sergeant, continuing with his administrative duties as the desk sergeant. Although usually deskbound, he managed to get into the field and do some ranging. He served at the Morenci mining strike in 1903 and, in 1905, accompanied Captain Rynning to dangerous Sonora, Mexico, to retrieve the body of an American mining engineer who had been murdered and buried. In 1906, during the Cananea, Sonora, Mexico, mining strike, Hopkins was commissioned by a Mexican official to serve as a volunteer lieutenant colonel. (Courtesy of Arizona Rangers Museum and Archives.)

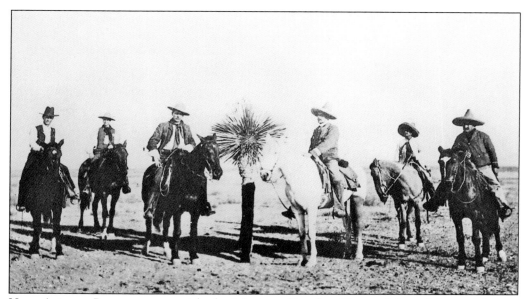

Here Arizona Rangers meet with the Mexican Rurales. Pictured from left to right are Pvt. Samuel J. Hayhurst (1903–1909), Sgt. Arthur Hopkins, Capt. Thomas Rynning, Col. Emilio Kosterlitzky, and two unidentified Rurales. (Courtesy of Arizona State Library, Archives, and Public Records, Archives Division, Phoenix, No. 96-2374.)

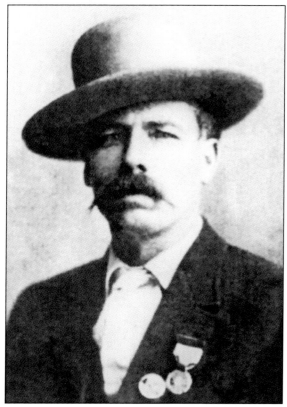

Sgt. James E. McGee (1904–1906) was born in Arkansas and enlisted at age 34. Seen here on a political campaign following his discharge, he was ultimately elected sheriff of Pinal County. (Courtesy of Arizona Rangers Museum and Archives.)

25

A native Arizonan, Pvt. Ruben L. Neill (1904–1906) enlisted at the age of 28. He is pictured some years earlier while working on a survey crew. Neill went on to serve as a deputy sheriff for Coconino County for 14 years and "was Chief of Police at Flagstaff and Winslow. In all, Neill wore a badge in Arizona for thirty-five years," noted Bill O'Neal. (Courtesy of Arizona Rangers Museum and Archives.)

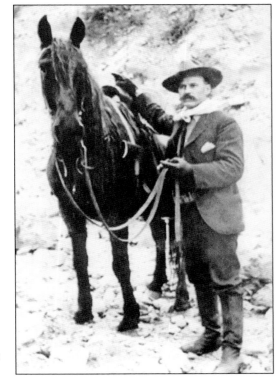

Pvt. Clark H. Farnsworth was a former deputy sheriff who was born in Illinois and enlisted in 1905 at the age of 31. He served for only a few months. (Courtesy of Arizona Rangers Museum and Archives.)

Lt. John Brooks poses with a heavy "Border Belt" loaded with ammunition and six-gun. (Courtesy of Arizona Rangers Museum and Archives.)

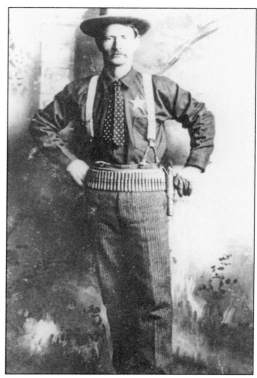

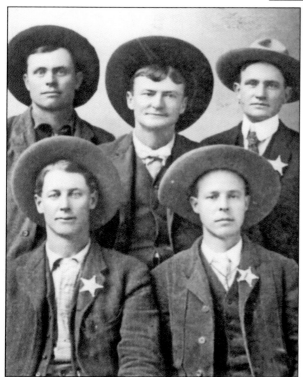

In this rarely seen 1906 studio photograph are, from left to right, (first row) Jeff Kidder (1903–1908) and Arthur A. Hopkins; (second row) William S. "Billy" Speed (1906–1909), William A. "Billy" Old (1904–1909), and Chapo Beaty. Two of these rangers would die violently. The first, Sergeant Kidder, died as a result of a gunfight with Mexican police in Naco, Sonora, Mexico. The gunfight caused something of an international uproar and was eventually resolved because of a technicality over Kidder's ranger commission. It is said that Lieutenant Old, Kidder's best friend who also named his son after him, left the Rangers and journeyed into Mexico to avenge Kidder. Down there for about two years, from 1909 to 1911, he allegedly accomplished his mission. Billy Old was known to be something of a ladies man and died in 1914 as a result of a gunshot wound administered by his wife. (Courtesy of Kathy L. Goodwin.)

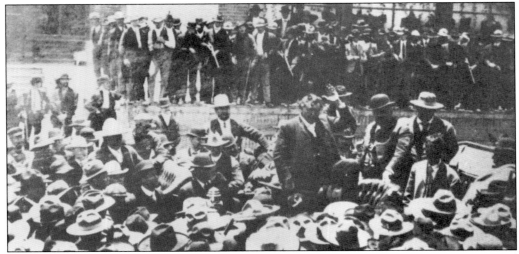

On June 1, 1906, the American-owned Cananea Consolidated Copper Company experienced a Mexican labor strike that turned into an emergency as hostilities grew with arson, rowdiness, and death threats. Local citizens requested help, and Rynning took it upon himself to lead an unauthorized rescue expedition to Cananea. He rounded up volunteers, some Rangers and former Rangers, for a total of over 250 men. Rynning was able to establish some order by threat of force, and Colonel Kosterlitzky arrived a bit later with his Rurales and further established order with ruthless volleys of gunfire, hangings, and firing squads. A Mexican official had commissioned Rynning as a volunteer colonel during this episode, but Governor Kibbey was not amused. After explaining his actions, Rynning appeased the governor and was hailed a hero by Arizonans. (Courtesy of Southwest Studies, Scottsdale Community College.)

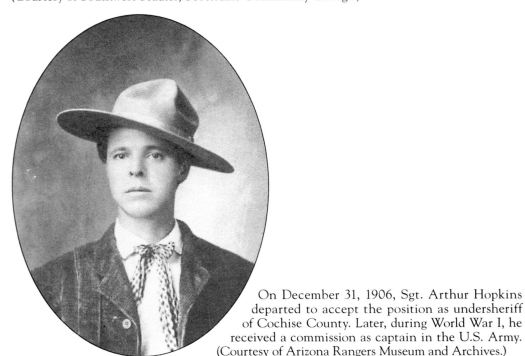

On December 31, 1906, Sgt. Arthur Hopkins departed to accept the position as undersheriff of Cochise County. Later, during World War I, he received a commission as captain in the U.S. Army. (Courtesy of Arizona Rangers Museum and Archives.)

Pvt. Jesse W. Rollins (1906–1907) was born in Utah and enlisted at age 34. He was involved in the arrest of a Mexican horse rustler wanted "by Sonoran officials," according to Bill O'Neal. The rustler had been chased "into Cochise County near Douglas," with Rollins and Pvt. Sam Hayhurst tasked with his arrest. They located the rustler near Douglas after his wife had attempted to conceal him. While awaiting extradition in the Douglas jail, the rustler stated that he had "deep regret at being in trouble," as he should, "since horse thieves usually were shot in Sonora." (Courtesy of Arizona Rangers Museum and Archives.)

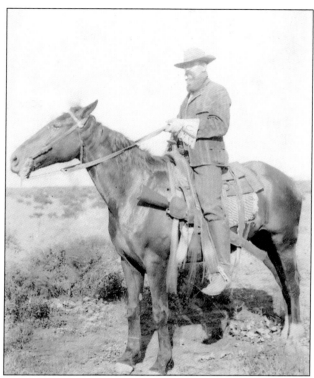

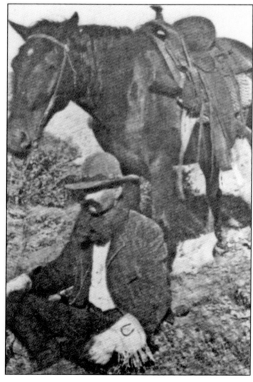

Pvt. Jesse Rollins takes a break while in the field. (Courtesy of Arizona Rangers Museum and Archives.)

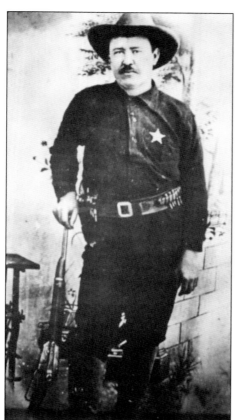

An unidentified Ranger poses in a photographic studio with all the customary equipment required for carrying out his duties. He is wearing his badge, handgun, carbine, and ammunition and probably carrying a pair of handcuffs. Badge, gun, and handcuffs are the basic tools of the trade and are occasionally referred to today as "the heavy metal trinity." (Courtesy of author.)

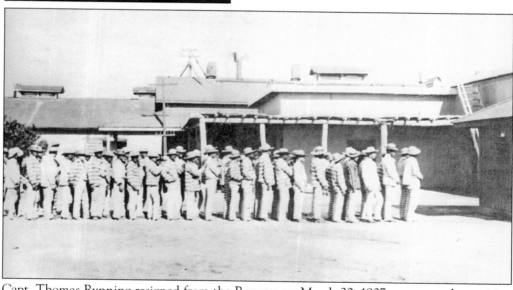

Capt. Thomas Rynning resigned from the Rangers on March 20, 1907, to accept the position as final superintendent of the Yuma Territorial Prison. During his time as a Ranger, he had provided a steady supply of guests to the prison "Hell Hole." (Courtesy of Southwest Studies, Scottsdale Community College.)

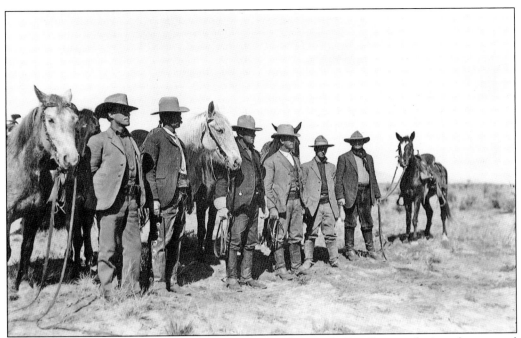

About 1907, Capt. Harry Wheeler (left) is pictured with several of his Rangers during a large patrol in the vicinity of Willcox. Dane Coolidge—a naturalist, photographer, and writer—took this and the following nine photographs. He ventured out into the territory to experience and document the waning West and those occupations that were fading in the early 20th century. Coolidge went on to write a number of books and novels based upon his experiences and observations. (Courtesy of Arizona Historical Foundation.)

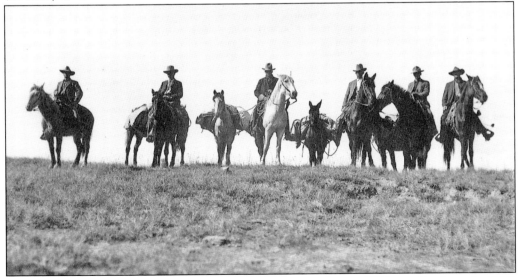

Captain Wheeler's patrol looks down from high ground near Willcox. On June 1, 1907, Wheeler published six General Orders for his Rangers. The General Orders were issued to establish behavioral, enforcement, investigative, operational, and moral standards. (Courtesy of Arizona Historical Foundation.)

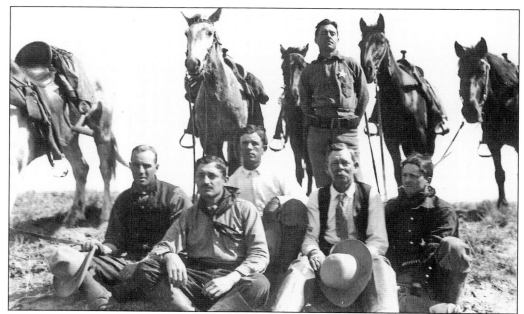

Captain Wheeler stands behind his Rangers during a trail break near Willcox. General Order No. 1 stated the following: "Rangers will not congregate in saloons; nor in any bawdy house, for the purpose of amusement, or out of idleness. This is not intended to interfere with any Ranger acting in his official capacity; nor to prevent his taking a drink if so inclined; nor the exercise of any right or privilege in which a gentleman would feel safe." (Courtesy of Arizona Historical Foundation.)

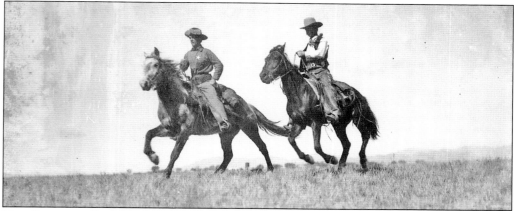

Here Rangers gallop along on their mounts near Willcox. General Order No. 2 is as follows: "It being a well established fact that men of honor, will meet their just, financial obligations on time and according to promise, the attention of all Rangers is called to the evil of going beyond their means, and for any reason borrowing or contracting loans they will be unable to meet. The reputation of this company has been *very* high, but of late one or two incidents, which have come to my notice, have caused me much embarrassment and humiliation. All Rangers must meet their obligations. Every man is a guardian of the honor and reputation, not only of himself, but the entire organization. It is every man's duty to aid in perpetuating the integrity of the service, by unmasking any undesirable member, who by accident may be among us." (Courtesy of Arizona Historical Foundation.)

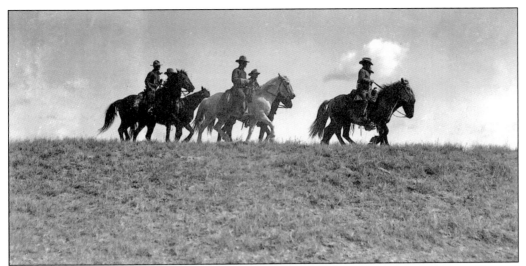

Near Willcox, Rangers patrol along the skyline in a double-abreast column formation. General Order No. 3 states, "Every man is hereby prohibited from entering Mexico in any *official capacity* whatsoever, armed or unarmed. Unless by special request or permission of the Mexican authorities, and being accompanied by some Mexican Official. Even under such conditions, Rangers will remember they go *unofficially,* and simply as any other private citizen." (Courtesy of Arizona Historical Foundation.)

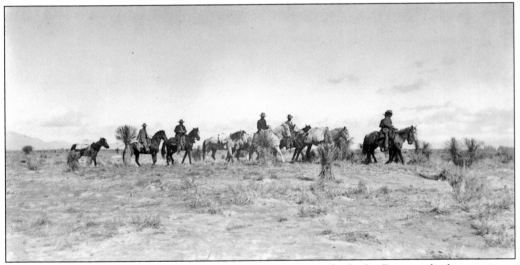

This patrol photograph shows the harsh desert terrain in which the Rangers had to navigate and survive, sometimes for weeks at a time. According to General Order No. 4, "All Rangers will enforce strictly and impartially, the laws which prevent gambling, women and minors in saloons, etc. All laws will be enforced, but I desire extreme vigilance and precaution upon the part of Rangers, in preventing the violation of the laws above mentioned. We all know that gambling has caused more suffering and crime, serious crime, than any other dozen causes combined. In my opinion, the complete suppression of this evil, will result in a falling off, of at least 50% of the arrests for Felonies. Consequently lessening the needs of hundreds of women and children, who have known want and privation hereto fore. I consider it an honor to any man, or organization, who aids in suppressing this evil." (Courtesy of Arizona Historical Foundation.)

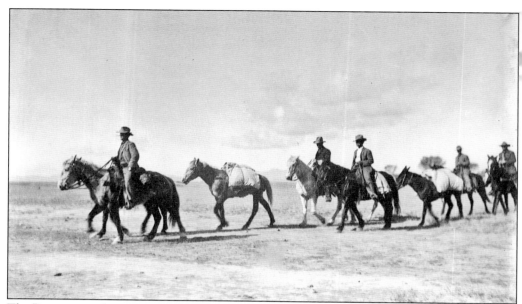

The Ranger patrol continues to search for outlaws near Willcox. General Order No. 5 read, "In all cases where prisoners are taken, the greatest humanity will be shown, and each Ranger is instructed to mentally place himself in the others place and act, legally, accordingly. I want no man to needlessly endanger his life by taking foolish chances with desperate criminals, and if any one man must be hurt, I do not want it to be a Ranger, at the same time I want every precaution taken to insure a peaceful arrest, and in all cases, when an arrest has been consummated the prisoner must be shown the courtesy due an unfortunate, and the kindness a helpless man deserves and gets from a brave officer." (Courtesy of Arizona Historical Foundation.)

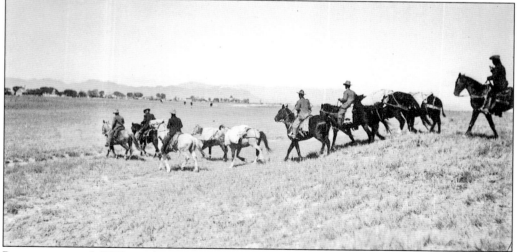

Rangers approach Willcox, the town seen in the distance. General Order No. 6 states, "The new monthly reports will be made out the first day of each new month and sent to Headquarters. Every item must be filled out and the report certified to on the back. In addition that I may keep in constant touch with all members, a postal card will be sent into Headquarters, each Saturday, telling where you are and where you may be reached for the next few days, as nearly as possible." (Courtesy of Arizona Historical Foundation.)

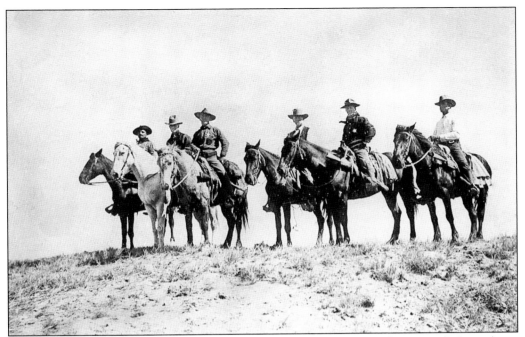

In one of the more well-known and reproduced photographs of the Willcox patrol, the stalwart lawmen pause along the skyline with their carbines and badges prominently displayed. (Courtesy of Arizona Historical Foundation.)

This photograph appears to be another from the series taken by Dane Coolidge. It is difficult to determine just what these Rangers are doing. Are they conducting training, a reenactment, or a rehearsal, or just relieving themselves with the horses turned away so as not to embarrass them? (Courtesy of Arizona Historical Society, Tucson, No. 91475.)

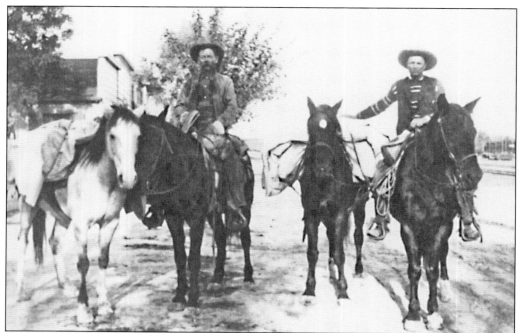

J. T. "Rye" Miles (1907–1908), left, and Jeff Kidder, seen with their packhorses, are ready for field duty. Sgt. Rye Miles was born in Texas and enlisted at the age of 41. After his enlistment expired, he went on to serve as a Pinal County deputy sheriff, Benson constable, Cochise County deputy Ranger, and Arizona State Prison guard. "During the thirty years that he wore one badge or another, he killed four men," according to *The Arizona Rangers*. Miles died in 1942 at 76 years of age. (Courtesy of Arizona Rangers Museum and Archives.)

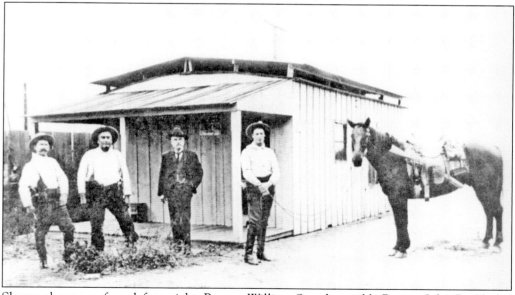

Shown above are, from left to right, Ranger William Speed, possibly Ranger John R. Clarke, Justice of the Peave in Naco V.R.N. Greaves, and Sgt. Jeff Kidder. (Courtesy of Arizona Rangers Museum and Archives.)

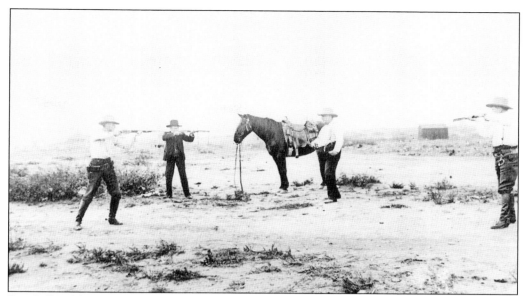

Sgt. Jeff Kidder (left, pointing the carbine) conducts a training exercise or possibly an arrest reenactment about 1907. (Courtesy of Arizona Rangers Museum and Archives.)

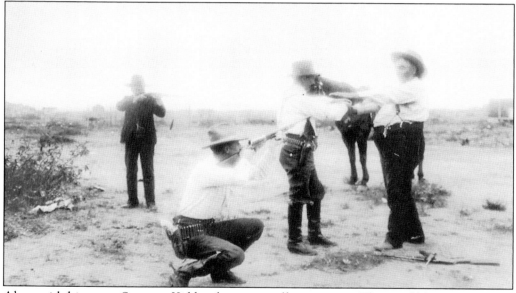

Along with his posse, Sergeant Kidder closes in to affect an arrest. This would have been a very dangerous suspect, considering all the firearms being displayed. Kidder was the second Ranger to die in the line of duty. For several decades, there was controversy over whether he really was in the line of duty. After his enlistment had expired, he traveled to Naco, Sonora, on April 4, 1908, to do some investigating. While in a cantina back room with a señorita, he became involved in a running gunfight with Mexican police. He was severely beaten and taken into custody. Other Rangers attempted to gain his release, and Kidder was able to make statements prior to his death the following day, some 30 hours later. A serious animosity was directed toward Rangers in the corrupt border town, and there was evidence that Jeff Kidder had been set up by police and the señorita. (Courtesy of Arizona Rangers Museum and Archives.)

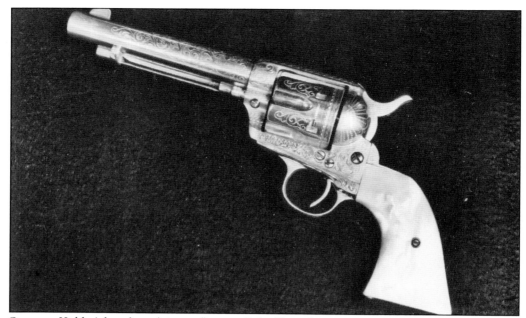

Sergeant Kidder's handgun (pictured) was a Colt .45 single-action revolver with pearl grip stocks. Kidder was known as one of the most accurate and quickest shooters in the Arizona Territory. His ambition had always been to be a "top-notch gunfighter," and he found the perfect profession for doing so. He was involved in numerous scrapes, with some rating a "gun-notch," including one in Bisbee in 1904 when he used his handgun to pistol-whip three miscreants into submission. Unfortunately the locals thought the act a bit heavy handed. After the lynching talk settled down, Kidder was eventually convicted of one count of assault and battery and fined $50. (Courtesy of Arizona Rangers Museum and Archives.)

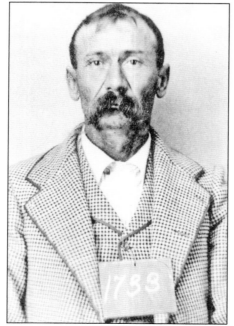

Seen in this prison mug shot is William F. Downing, who finally met his demise in Willcox when confronted on August 5, 1908, by Pvt. Billy Speed and city constable Bud Snow. Downing had been terrorizing the community for some days, and at one point, Capt. Harry Wheeler had given instructions: "Upon his least or slightest attempt to do you harm I want you to kill him." With an arrest warrant in hand for an earlier beating of a saloon girl, Private Speed and Constable Snow went to the Free and Easy Saloon, where Downing had made threats about killing Speed. Downing had been drinking all night and departed the saloon, leaving his handgun behind the bar. Ranger Speed confronted Downing in the street, ordering him to surrender. Downing initially raised his hands and then attempted to draw the missing handgun from his hip pocket. Speed fired one round from his Winchester, striking Downing in the chest. Although Downing was unarmed, he had contributed to his own demise. Billy Speed was exonerated by witnesses. (Courtesy of Yuma Territorial Prison State Historic Park.)

In this rarely seen photograph is Capt. Harry Wheeler with all his hardware. (Courtesy of Arizona State Library, Archives, and Public Records, Archives Division, Phoenix, No. 01-4556.)

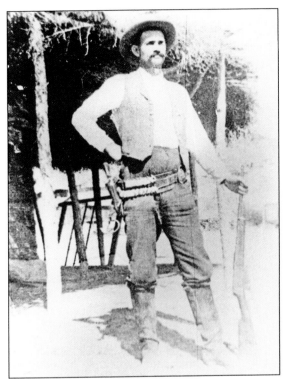

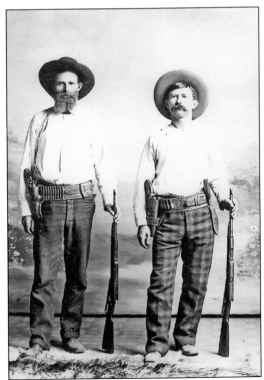

Two lawmen pose in a studio setting with their hardware. The Ranger at right is Sgt. William "Timberline Bill" Sparks. In 1905, Sergeant Sparks was involved in a unique investigation of the chief deputy sheriff of Graham County, Lee Hobbs. It was not popular to arrest fellow lawmen, but Hobbs was considered to be no good and had "shot a man to death shortly after his appointment," according to Bill O'Neal. Sparks conducted the investigation that resulted in Hobbs's arrest and extradition "for mutiny and murder on the high seas." (Courtesy of Arizona State Library, Archives, and Public Records, Archives Division, Phoenix, No. 96-2380.)

These three Rangers of the Northern Detachment were placed in three different locations in 1908: Lt. William A. "Billy" Old (left, 1904–1909), headquartered in Williams; Pvt. Cy Byrne (center, 1907–1909), stationed at Juniper; and Pvt. Samuel C. Black (1908), stationed at Flagstaff. (Courtesy of Arizona Rangers Museum and Archives.)

Pvt. John McKittrick Redmond (1908–1909) was born in New York and enlisted at age 24. Posing with his Winchester carbine and trusty steed, he tracked horse thieves "for five days after the company had been abolished" by legislation on February 15, 1909, said Bill O'Neal in *The Arizona Rangers*. (Courtesy of Arizona Rangers Museum and Archives.)

This state document, dated August 4, 1905, appoints Ranger William A. Old as a sergeant. (Courtesy of Arizona State Library, Archives, and Public Records, Archives Division, Phoenix.)

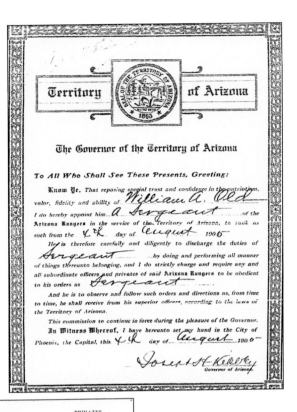

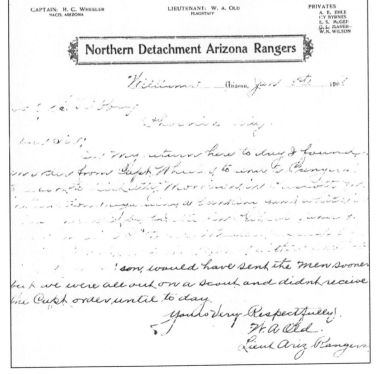

Using Northern Detachment letterhead, Lt. W. A. Old addressed this correspondence to Gov. Joseph Kibbey on January 8, 1908. (Courtesy of Arizona State Library, Archives, and Public Records, Archives Division, Phoenix.)

ARIZONA RANGERS

To all whom it may concern:

This is to Certify that _____Rudolph Gunner_____

a ____Private____ of the Arizona Rangers, who was

enlisted the__10th__day of ____December____ one thousand nine

hundred and ___Eight___ to serve ___one Year___

is hereby discharged from the service of the Territory in consequence

of ____Resignation____

Given under my hand at ____Naco,____ this__9th__day

of __January__ one thousand nine hundred and__Nine.__

Harry C. Wheeler
Captain Arizona Rangers

CHARACTER
Good

EXECUTIVE DEPART. OF ARIZONA
OFFICE OF THE GOVERNOR
Phoenix, Arizona, July 25 1904
Approved

Harry C. Wheeler
Commanding Company

Joseph H. Kibbey
Governor

Dated January 9, 1909, this document discharges Pvt. Rudolph Gunner. The reason for the discharge reads "resignation," with the character section reading "good." Since he enlisted on December 10, 1908, it appears that Private Gunner's duty was cut short by about 11 months. The remarks section on the back side of the document reveals the possible issue: "A good man when not drinking." However, Gunner's career in the Arizona Rangers would have been short-lived anyway, for on February 15, 1909, after much debate and political pandering, the Arizona Rangers were legislated out of business. (Courtesy of Arizona State Library, Archives, and Public Records, Archives Division, Phoenix.)

Harry C. Wheeler
Enlisted July. 6 1903. Douglas, Capt.T.H.Rynning
Re " " " 1904, " " " "
Re " " " 1905 " " " "
Commissioned Lieutenant, July 11. 1905, Gov.J.H.Kibbey

Discharged July 6.1904, Expiration of Term
" " " 1905 " " "

Appointed 4th. Sergeant. Oct. 15.1903,
" 3rd " Nov. 1. 1903.
" 2nd " Aug 7. 1904,

Commissioned Captain March 2 - 1907,

Killed Joe Bostwick. Tucson. Oct 31. 1904, resisting arrest + Holdup
Killed J. A. Tracy, Benson Oct. 28 1907, resisting arrest + Murder
Killed George Arnett with Dep. Rhimes May 5-'08
horse thief who resisted arrest by shooting
Field Dep U.S. Marshal
Wounded - thigh + foot - Benson Feb 28 '07.

Pictured is an example of the handwritten personnel record keeping likely maintained by the desk sergeant. This page, taken from Capt. Harry Wheeler's final service record, includes entries about appointments, commissions, gunfights with results, and wounds received. After wrapping up administrative matters, on March 25, 1909, Captain Wheeler became the last Ranger to depart his post. (Courtesy of Arizona State Library, Archives, and Public Records, Archives Division, Phoenix.)

Two

THE INTERIM DECADES
1909–1957

The decades following the demise of the Arizona Rangers would prove even more dangerous. It can be effectively argued that the Rangers were needed more than ever. The Mexican Revolution, which was in reality a civil war, started in 1910 and brought along with it significantly more border problems including various criminal activities, border battles and raids, rustling, smuggling, and waves of both war and economic refugees for decades to come. After statehood in 1912, the Arizona National Guard was deployed, along with other state guard units and federal troops, but its role was largely one of security rather than crime fighting, and its presence declined dramatically as the United States entered World War I in 1917. In 1904, the U.S. Customs Service had established mounted inspectors, with Capt. Harry Wheeler serving from 1909 to 1911; however, they were far outnumbered and spread thin in the border region.

The Volstead Act was passed in 1919 and enacted in 1920. The border again became a haven for criminal activity, as liquor smuggling proved lucrative for those who would capitalize on this most unpopular legislation. In 1924, the forerunner of what would become the U.S. Border Patrol was established to stop both liquor and illegal immigration, but was again outnumbered and overrun. The next state law enforcement agency would be a small Arizona Highway Patrol established in 1931 with the primary mission of traffic enforcement and safety. Eventually, in 1969, the state would establish a Department of Public Safety with far-reaching law enforcement responsibilities. Thus, for over 60 years, between 1909 and 1969, Arizona essentially had no all-inclusive state law enforcement agency. Surely the Arizona Rangers would have proved effective and could have also merged into the Arizona Department of Public Safety.

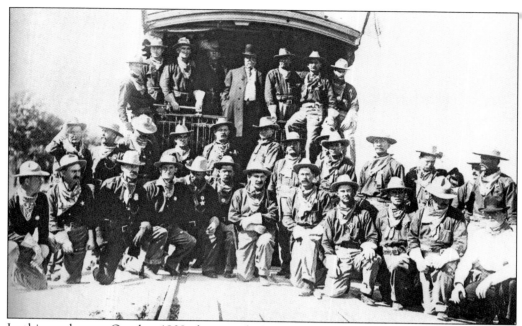

In this rarely seen October 1909 photograph, Pres. William H. Taft, who journeyed by train through the South and Southwest to California, meets with numerous peace officers from around the territory. President Taft's railroad tour of the southwestern territories was well publicized, as both Arizona and New Mexico were seeking statehood. It is quite possible there is a former Ranger among the lawmen. (Courtesy of Raymond Sherrard.)

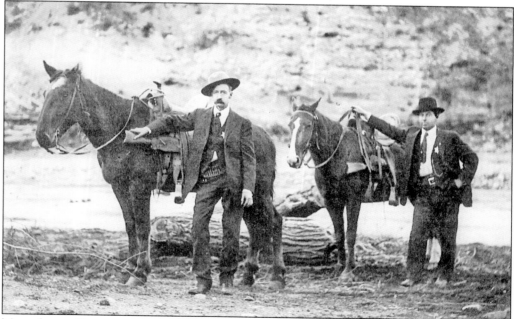

Many former Rangers continued on in law enforcement, such as Robert M. Anderson (left), who became Globe city marshal. He is seen here with one of his deputies. (Courtesy of Arizona Rangers Museum and Archives.)

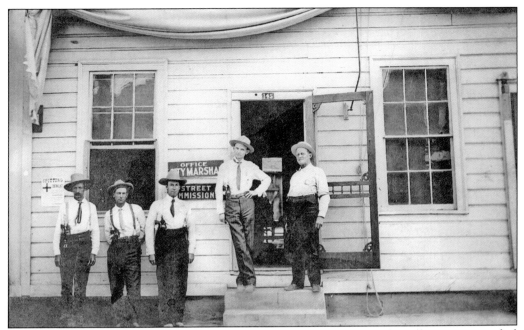

Former Arizona Ranger Robert Anderson (far left) is pictured in front of his office as city marshal of Globe. (Courtesy of Arizona Rangers Museum and Archives.)

Superintendent Tom Rynning closed down the prison in 1909, and the inmates were transferred to the new Arizona State Prison at Florence. He served as the first warden until 1912, when political appointments changed in favor of Democrats. Moving to San Diego, California, Rynning revisited his role as warden in 1921, after the Republicans returned to power. Back in California, Rynning became a deputy U.S. marshal and undersheriff of San Diego County. He died at his San Diego residence in 1941. (Courtesy of Southwest Studies, Scottsdale Community College.)

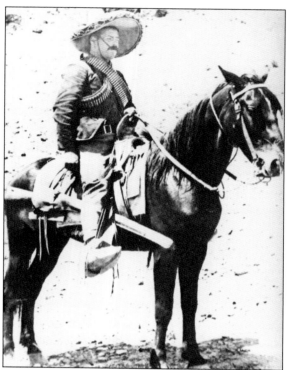

The Mexican Revolution started in 1910 and raged on for a decade. The fighting created such infamous leaders as Gen. Pancho Villa, also known as "the Centaur of the North," who commanded the Division Del Norte. Villa's troops were active all along the border between Arizona and Texas, requiring American troops to be deployed to the area in 1915. Pancho Villa invaded the United States on March 9, 1916, by attacking Columbus, New Mexico, which resulted in a U.S. Army Punitive Expedition into Mexico. The expedition began on March 15, 1916, and lasted until late February 1917 as the troops withdrew. Just as Texas had used its Rangers, certainly Arizona also could have used them about this time. (Courtesy of Southwest Studies, Scottsdale Community College.)

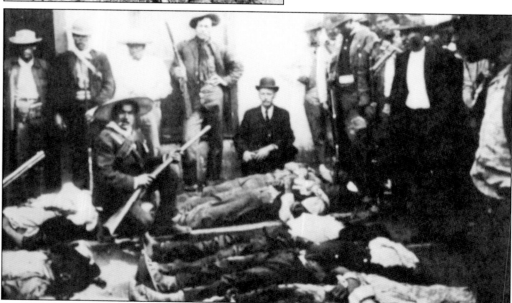

Battles in Mexican border towns were fierce and on occasion spilled over onto American soil. This 1911 photograph shows some of the dead lined up after the Battle of Agua Prieta, Sonora, which is located opposite Douglas, Arizona. Other battles along Arizona's border with Mexico included Nogales, Sonora, on March 13, 1913, adjacent to Nogales, Arizona; and Naco, Sonora, between 1913 and 1916, adjacent to Naco, Arizona. (Courtesy of Southwest Studies, Scottsdale Community College.)

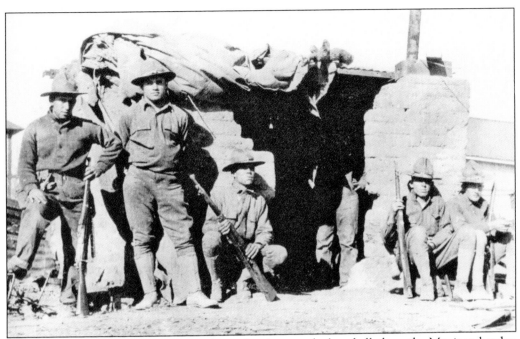

In 1915, both federal and state national guard units were deployed all along the Mexican border. This particular outpost was situated in Naco. (Courtesy of Fort Huachuca History Museum.)

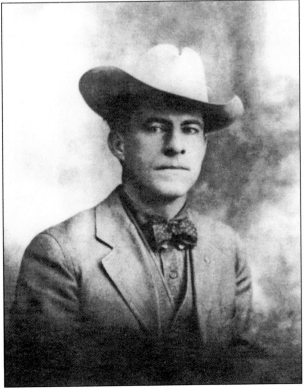

After leaving the Rangers, Capt. Harry Wheeler served as a Cochise County deputy sheriff, a U.S. Customs Service mounted inspector, and three-time sheriff of Cochise County. When America entered World War I, he joined the army after much difficulty and effort. He was commissioned a captain and made it to France before being sent home to Arizona to face charges for the Bisbee Deportation (a labor dispute where Wheeler deported problematic strikers), which he had enforced as sheriff. Captain Wheeler was reassigned to Fort Huachuca to command a machine gun company during the proceedings. The case dragged on until 1920, long after the war had ended. Wheeler became a special officer in Douglas and entered into competitive pistol and rifle shooting. He died of pneumonia on December 17, 1925, and was buried at the Evergreen Cemetery in Bisbee. (Courtesy of Arizona Rangers Museum and Archives.)

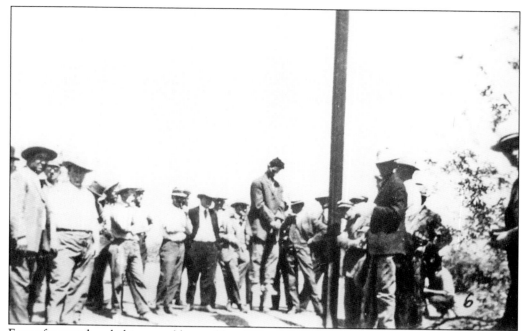

Even after statehood, things could get wild and Western, as evidenced by this lynching near Apache Junction on May 6, 1917. The murder and rape suspect was seized from deputies, driven to the crime scene location, and lynched by throwing the rope over the cross arm of a telephone pole. A vehicle rather than a horse was pulled out from under him. (Courtesy of Southwest Studies, Scottsdale Community College.)

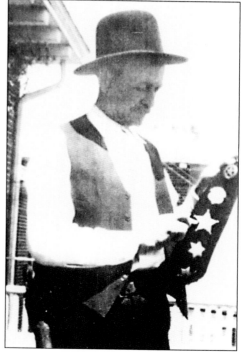

In this 1930s photograph, Pvt. Bud Bassett points to the Arizona Rangers badge, which is displayed along with other badges he wore during his peace officer career. Sworn in by Capt. Tom Rynning, he served at Morenci and, along with Lt. John Foster, captured the main ringleader of the strike. After leaving the Rangers, Bassett served as a Yuma Territorial Prison guard, as a deputy sheriff in Maricopa, Cochise, Mohave and Yavapai Counties, and as a state cattle inspector. "His final job was as a night watchman for the Arizona Highway Department," noted Bill O'Neal. At 74 years of age, "he was the oldest active law officer in the United States," and his "career was capped by being appointed an honorary deputy sheriff of all fourteen Arizona counties." (Courtesy of Arizona Rangers Museum and Archives.)

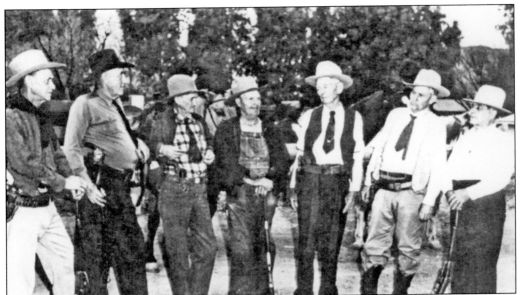

Former Rangers posing in 1940 are, from left to right, Pvt. William C. Parmer (1908–1909), Pvt. Owen C. Wilson, Pvt. James D. Bailey, Pvt. Charles A. Eperson (1903–1906), Sgt. Rye Miles, Pvt. Joseph H. Pearce (1903–1905), and Pvt. Charles McGarr (1905–1907). About a year earlier, former Rangers met in Phoenix to reorganize a social organization by the name Arizona Rangers with the purpose of meeting annually. This photograph could possibly be the following year's reunion, with the occasion being the group's participation in the Prescott Rodeo Parade. (Courtesy of Arizona Rangers Museum and Archives.)

Capt. Burt Mossman is shown here in the 1940s. (Courtesy of Arizona Rangers Museum and Archives.)

Pvt. Cy Byrne, pictured years after the Rangers disbanded, had served with Lt. Billy Old's Northern Detachment. (Courtesy of Arizona Rangers and Archives.)

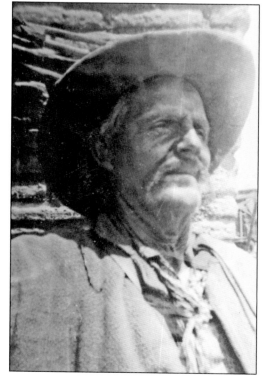

Born in California and enlisted at age 26, Pvt. Charles A. Eperson is seen at age 63 in an acting role in the 1940 motion picture *Arizona*. As a Ranger in 1906, he had been accused by an arrestee of using excessive force. When Eperson was exonerated, the August 8, 1906, *Tucson Citizen* newspaper commented that he "has a good record as an officer and has succeeded in making Gila Bend a peaceful hamlet." (Courtesy of Linda McConchie.)

Three

ARIZONA RANGERS RIDE AGAIN 1957–1999

In 1957, about 48 years after their service, four original Territorial Rangers—along with other interested parties—set out to reactivate the Arizona Rangers, with all of them also being involved in the new television series 26 *Men*, which debuted in 1958. The concept caught on as the organization grew from several Rangers to hundreds over the next 50 years. Although there is no accurate head count, it is estimated that several thousand Rangers have passed through the ranks. Reactivated as a civilian law enforcement auxiliary, over the years, the organization has had over 38 Ranger companies distributed throughout the state.

Like any volunteer organization, it has had problems and disagreements within its ranks, and as one Ranger said, "It's a miracle and a testimony to the organization that it has survived so long." Many of these companies no longer exist because they have disbanded, merged, or simply renamed. Like today, in the beginning, many of the Arizona Rangers were cowboys, firearms and Old West enthusiasts, blue- and white-collar folks who wanted to contribute to their communities and assist law enforcement in maintaining peace and safety. Through the decades, as professionalism was stressed, the Arizona Rangers evolved into an exceptional and unique volunteer law enforcement auxiliary.

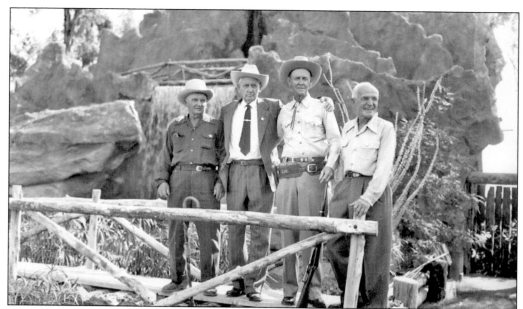

The four Arizona Territorial Rangers, on the set of television's *26 Men*, made brief appearances in the series and were instrumental in reestablishing the modern Arizona Rangers in 1957. The series debuted in 1958 and lasted only one season. Note the miniature badges on these elderly Rangers. Pictured from left to right are Sgt. Chapo Beaty, Pvt. Joseph Pearce, Pvt. William Parmer, and Pvt. John Redmond. (Courtesy of Arizona Rangers Museum and Archives.)

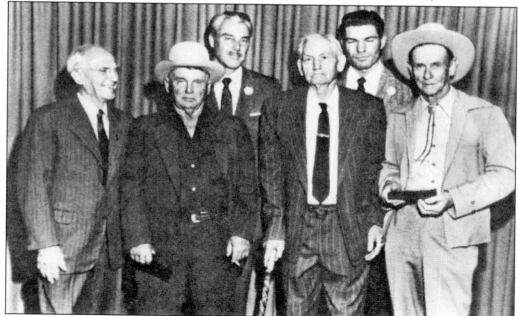

The Rangers pose with actors from the *26 Men* television series. Seen from left to right are the following: (first row) John Redmond, Chapo Beaty, Joseph Pearce, and William Parmer; (second row) Tris Coffin, who portrayed Capt. Tom Rynning; and Kelo Henderson, who portrayed a fictional Ranger with the name of Clint Travis. (Courtesy of Arizona Rangers Museum and Archives.)

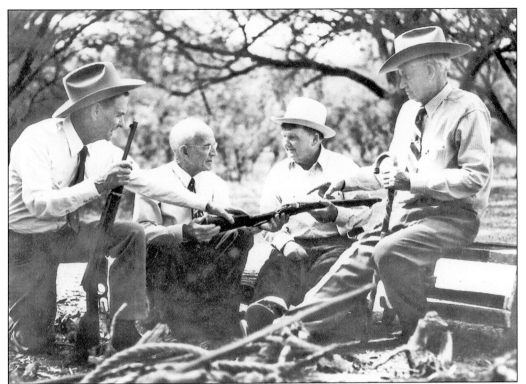

On the set of *26 Men*, the same four Arizona Territorial Rangers examine some of the hardware used in the old days. William Parmer (left) holds a Winchester Model 1895 carbine while John Redmond (left center) and Chapo Beaty (right center) handle a Winchester Model 1887 lever-action shotgun. Joseph Pearce is on the right. They all appear to be discussing the merits of the shotgun. (Courtesy of Arizona State Library, Archives, and Public Records, Archives Division, Phoenix, No. 96-2381.)

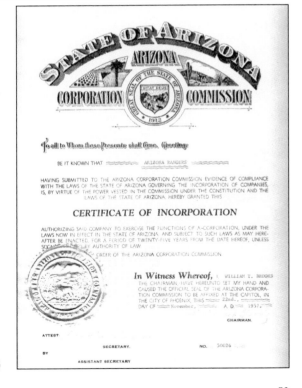

Shown here is the State of Arizona Certificate of Incorporation for the reestablishment of the Arizona Rangers, dated November 22, 1957. (Courtesy of Arizona Rangers Museum and Archives.)

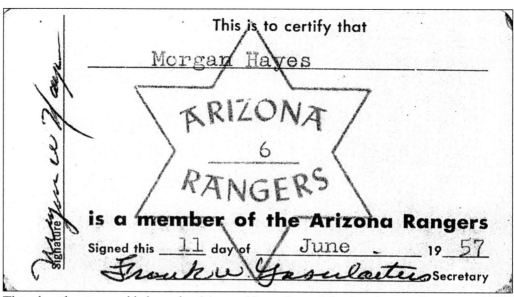

This identification card belonged to Morgan Hayes, "one of the first Arizona Rangers in 1957," according to the Arizona Rangers 2007 historical calendar. (Courtesy of Arizona Rangers Museum and Archives.)

This photograph was taken about five months prior to the official incorporation, on November 22, 1957. Three early Arizona Rangers, including Morgan Hayes (center), participate in a function at the El Rancho Shopping Center in Bisbee in the fall of 1957. Note the oversized badges. Bisbee would serve just like in the old days, as the first Arizona Rangers headquarters. (Courtesy of Arizona Rangers Museum and Archives.)

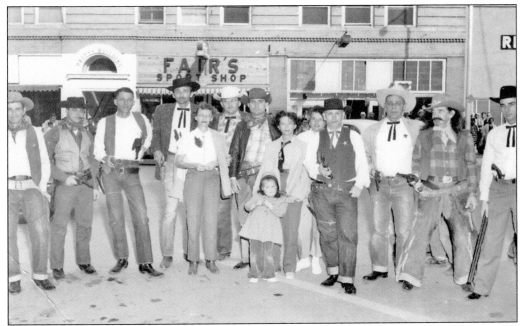

The newly reestablished Arizona Rangers are pictured at a civic event in Bisbee around 1957. Judging from their Western attire, it appears that these were the days of the waning B Western period in motion pictures. (Courtesy of Arizona Rangers Museum and Archives.)

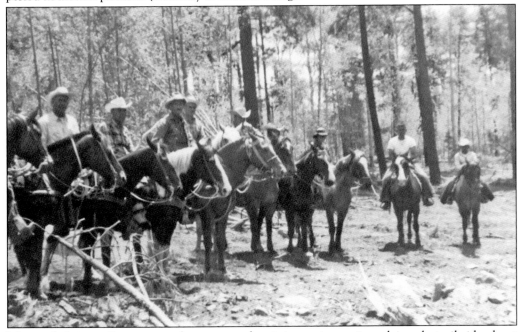

Mounted Arizona Rangers conduct mounted training or just enjoy a leisurely trail ride about 1958. The organization has attracted hundreds of equestrians since reactivation and naturally so, for just as the Arizona Territorial Rangers relied upon their trusty steeds, so do the modern Rangers. (Courtesy of Arizona Rangers Museum and Archives.)

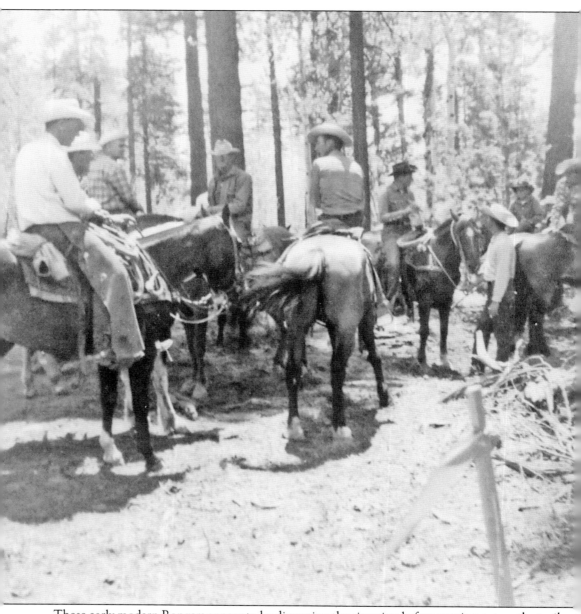

These early modern Rangers appear to be discussing the situation before moving out on the trail. (Courtesy of Arizona Rangers Museum and Archives.)

An Arizona Ranger swears in new enlistees around 1958. Although the modern Rangers are composed of volunteers rather than paid employees, they enlist and are sworn in just as the original Arizona Territorial Rangers were. The title of private, though, has fallen into disuse over the last 50 years. (Courtesy of Arizona Rangers Museum and Archives.)

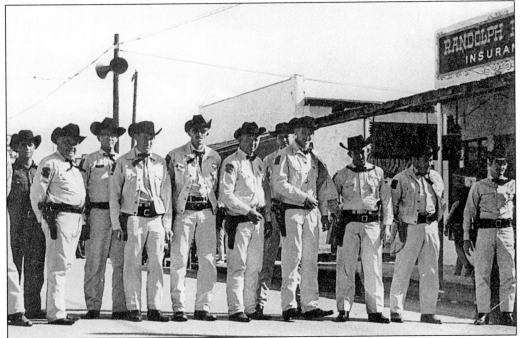

In 1962, Rangers from the Yuma and Huachuca Companies line up for joint duty as fully deputized peace officers. (Courtesy of Arizona Rangers Museum and Archives.)

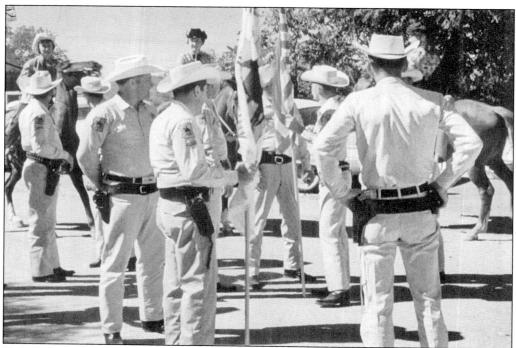

Tucson Company Rangers prepare for the parade in Tombstone in 1962. (Courtesy of Arizona Rangers Museum and Archives.)

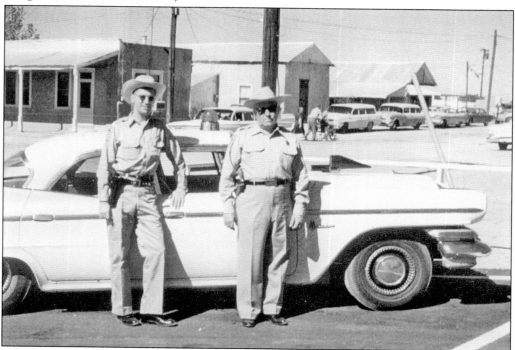

Two Huachuca Company Rangers are on duty in Tombstone in 1962. (Courtesy of Arizona Rangers Museum and Archives.)

Ranger Romero is shown on duty in Bisbee. (Courtesy of Arizona Rangers Museum and Archives.)

In 1963, two Arizona Rangers conduct foot patrol in Bisbee. At that time, all Rangers within Cochise County were special deputies under the command of the sheriff. (Courtesy of Arizona Rangers Museum and Archives.)

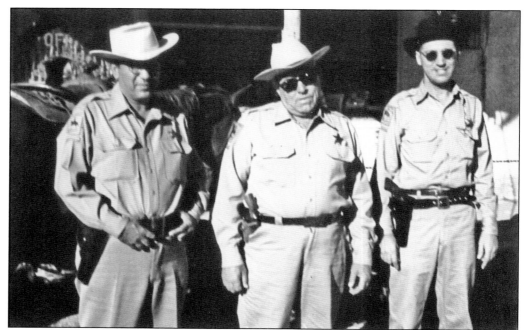

Arizona Rangers perform duties in Tombstone in 1963. (Courtesy of Arizona Rangers Museum and Archives.)

Shown here are Arizona Rangers while on duty in Tombstone. (Courtesy of Arizona Rangers Museum and Archives.)

Arizona Rangers engage in a discussion with a citizen. (Courtesy of Arizona Rangers Museum and Archives.)

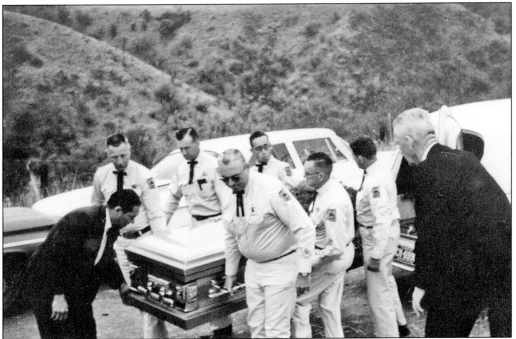

In Patagonia, Arizona Rangers act as pallbearers during the funeral of Sgt. Chapo Beaty. Chapo reached 90 years of age before dying on November 5, 1964. (Courtesy of Arizona Rangers Museum and Archives.)

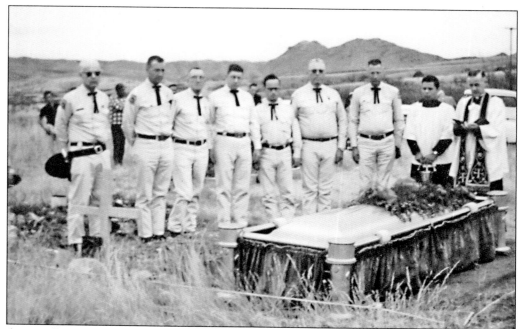

Arizona Rangers attend the graveside memorial service for Sgt. Chapo Beaty in 1964. (Courtesy of Arizona Rangers Museum and Archives.)

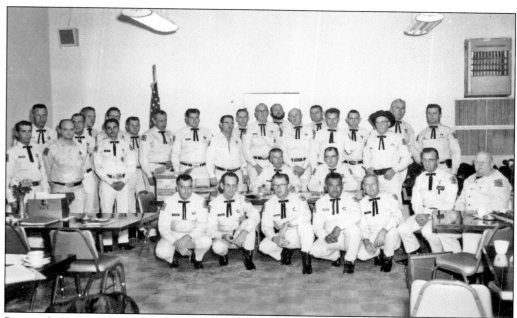

Pictured is a board of governors meeting at Parker in 1965. (Courtesy of Arizona Rangers Museum and Archives.)

The captain of Yuma Company (left) presents a plaque to one of his Rangers around 1961. (Courtesy of Arizona Rangers Museum and Archives.)

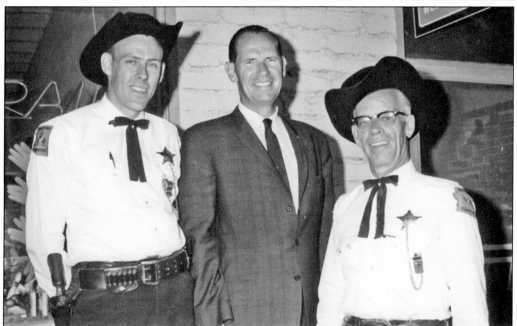

Rangers pose with Arizona governor Samuel P. Goddard. (Courtesy of Arizona Rangers Museum and Archives.)

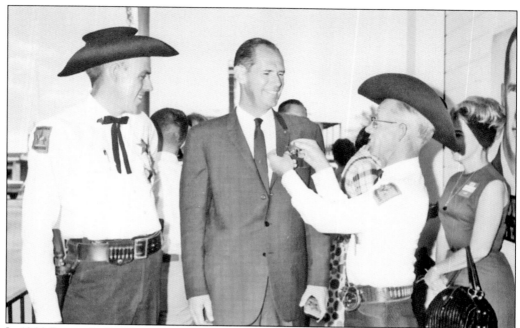

In 1966, Ranger L. G. "Shorty" Offret pins the Arizona Rangers badge on Gov. Samuel P. Goddard. Offret served as the state commander from 1970 to 1974. (Courtesy of Arizona Rangers Museum and Archives.)

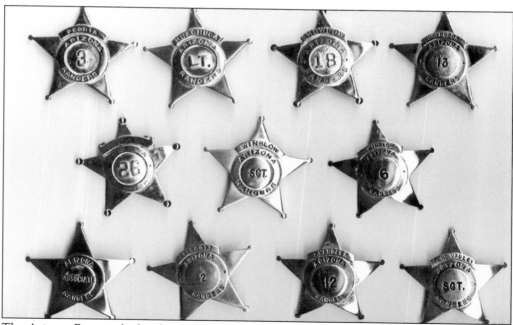

The Arizona Rangers badge design has changed over the years. These badges, worn during the 1960s and 1970s, identify a number of companies that were disbanded, merged, or renamed. (Courtesy of the Arizona Rangers Museum and Archives.)

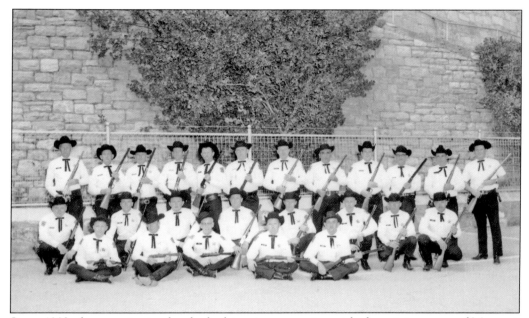

Since 1903, the organization has had a historic connection with the mining town of Morenci. Rangers are shown at Morenci on April 21, 1968. (Courtesy of Arizona Historical Society, Tucson, No. 19655.)

This Morenci photograph was also taken on April 21, 1968. (Courtesy of Arizona Historical Society, Tucson, No. 44699.)

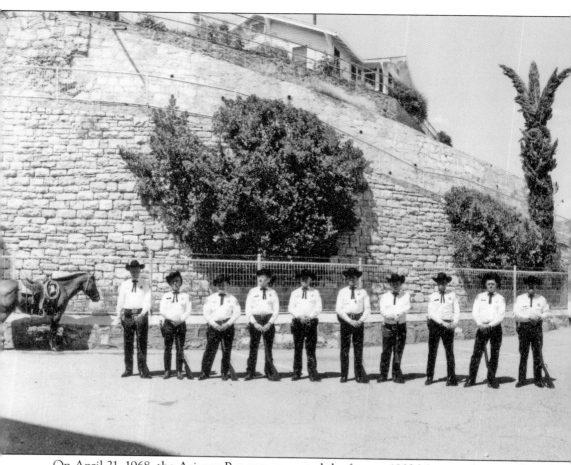

On April 21, 1968, the Arizona Rangers reenacted the famous 1903 Morenci photograph at the exact location where the original was taken. Although more Rangers were in attendance, only 25 were used in order to mirror the 1903 image. The horse on the left was also included. Pictured from left to right are Henry H. Martin, Shorty Offret, Niel Harrington, Victor J. Boucher,

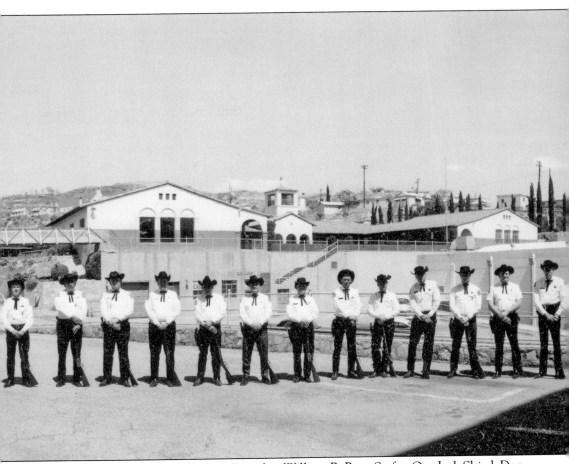

John O'Hanlon, Martin Dayton, Robert Towerlin, William B. Bray, Stefan Ott, Jack Shied, Don Sywassink, George McBride, Richard E. Kaehele, Lazaro Romero, D. Parkhurst, Philip Goldstein, Roy Flowers, R. B. Patchin, Harold Capps, Earl Hill, Paul McGee, Richard Dawe, David Schultz, Fred T. Keers, and Dean Runyon. (Courtesy of Arizona Historical Society, Tucson, No. 44421.)

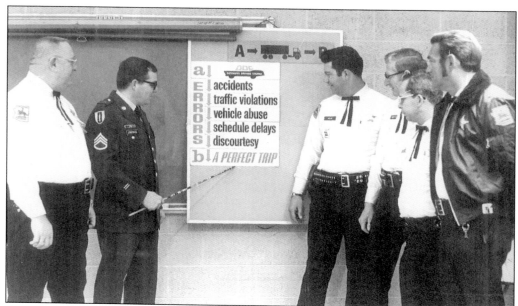

Arizona Rangers receive traffic control training from an army staff sergeant instructor at Fort Huachuca in 1974. (Courtesy of Arizona Rangers Museum and Archives.)

This photograph gives new meaning to the phrase "men in black." These Rangers are believed to be posing at Old Tucson Studios. (Courtesy of Arizona Historical Society, Tucson, No. 91479C.)

In 1975, Rangers from the Peoria Company participate in fund-raising and a bicycle raffle to benefit the Boys' Clubs of Phoenix. (Courtesy of Maj. Anita Korhonen.)

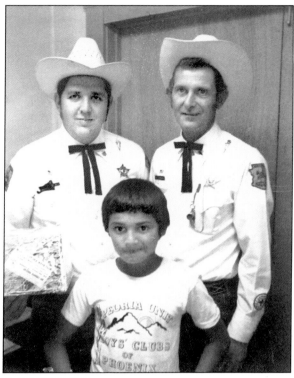

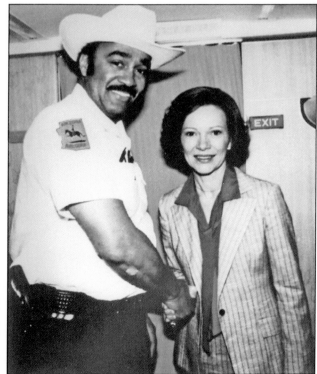

First Lady Rosalynn Carter thanks an Arizona Ranger for assisting the U.S. Secret Service in her personal protection. (Courtesy of Maj. Anita Korhonen.)

Rangers in the mounted unit of the Huachuca Company are seen here in 1981. Just like those of old, the modern Rangers find a horse to be useful for many types of duty. (Courtesy of Arizona Rangers Museum and Archives.)

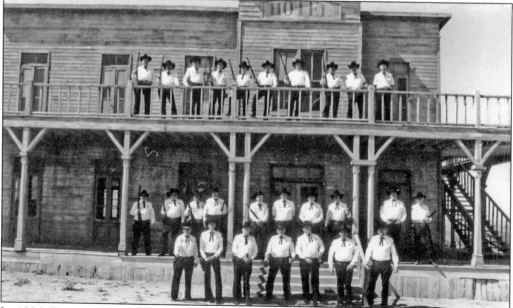

In 1986, Tucson Company stands in front of an Old West–style hotel. (Courtesy of Arizona Rangers Museum and Archives.)

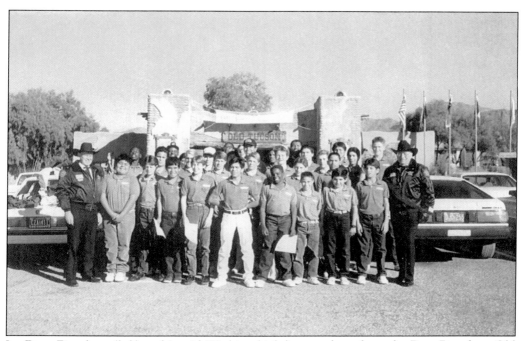

Lt. Dave Eisenberg (left) and Lt. Al Watkins (right) escort boys from the Boys Ranch to Old Tucson Studios in 1989. The Boys Ranch was one of the major recipients of Ranger support for years. (Courtesy of Arizona Rangers Museum and Archives.)

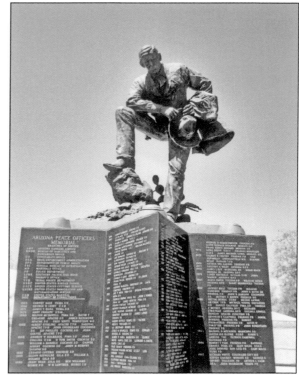

Located on the Capital Mall in Phoenix, the Arizona Peace Officers Memorial was dedicated on May 20, 1988. The impressive memorial carries the names of all the peace officers who have died in the line of duty while serving in the territory and state of Arizona. Only two of the three Arizona Rangers who were killed as a result of gunfire are listed. Rangers Carlos Tafolla (1901) and Jeff Kidder (1908) are honored, with Kidder's name being added in 1995 after some debate as to whether he actually died in the line of duty. Authorities determined that his enlistment expiration and the location of his death were technicalities. Ranger John W. Thomas is not listed because of another technicality: he was not serving as a peace officer as defined by the Arizona Penal Code. Arizona Rangers regularly participate at the annual memorial services. (Courtesy of author.)

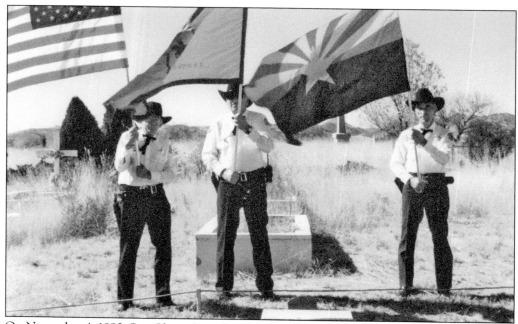

On November 4, 1990, Sgt. Chapo Beaty's grave site in Patagonia became the first Ranger grave to be honored with a ceremonial marking. Since then, over half of the Territorial Rangers' graves have been located and properly marked with ceremony and honors. The search for these grave sites continues to be a priority for the historical remembrance of the original Arizona Rangers. (Courtesy of Arizona Rangers Museum and Archives.)

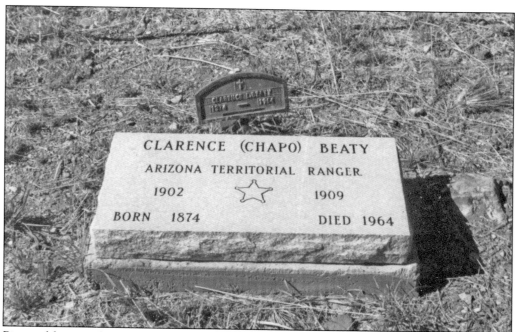

Pictured here is the marked headstone of Sgt. Chapo Beaty. (Courtesy of Arizona Rangers Museum and Archives.)

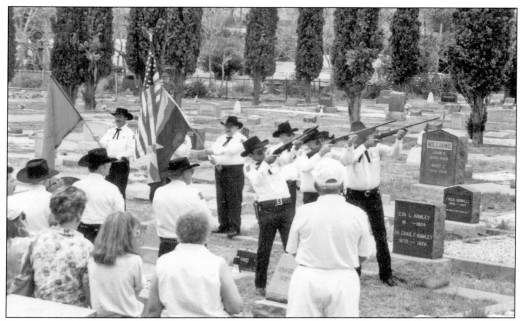

On August 14, 1991, the Arizona Rangers honored Capt. Harry Wheeler with a grave marking ceremony. A graveside memorial service with honor guard was conducted. (Courtesy of Maj. Anita Korhonen.)

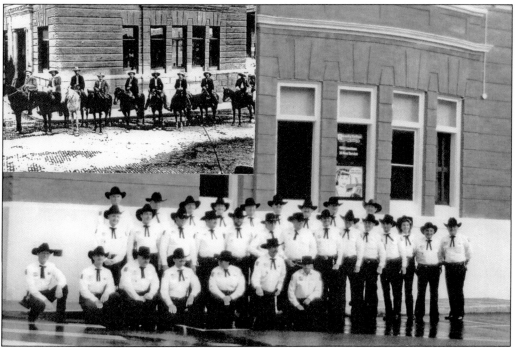

Arizona Rangers pose in July 1991 next to the Bank of Bisbee, the same location where the 1902 photograph was taken (see page 11). (Courtesy of Brig. Gen. Wendell W. Fenn, U.S. Army, Ret.)

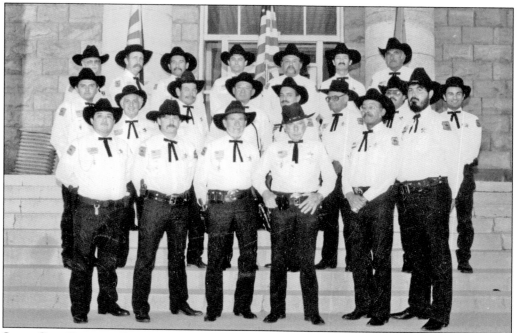

Santa Cruz Company Rangers pose for a company portrait on the steps of the 1904 Santa Cruz County Territorial Courthouse on August 6, 1993. Shown from left to right are the following: (first row) Luis Leva, Eric Bach-Wiig, Edward Niedkowski, John Dould, Samuel Jones, and Armando Madril; (second row) Gaston Mendez, Pat Auriemmo, Ramon Rodriguez, Elias Mahomar, Fernando Sedano, Art Cook, Hector de la Riva, and Jim Auriemmo; (third row) William Babb, James Luckey, Richard Ronquillo, Frank Grijalva, Rafael Mulero, Mario Moreno, and Stan Essig. (Courtesy of Arizona Rangers Museum and Archives.)

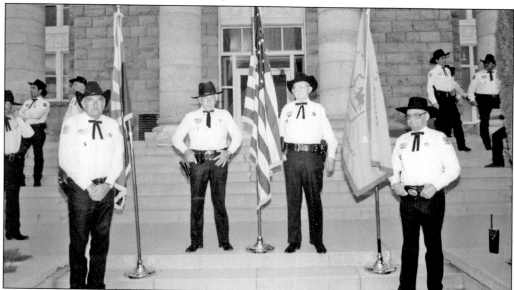

Members of Santa Cruz Company prepare to conduct a color guard ceremony at the 1904 Santa Cruz County Territorial Courthouse. (Courtesy of Arizona Rangers Museum and Archives.)

The Santa Cruz Company commander and staff stand on the steps of the 1904 Santa Cruz County Territorial Courthouse. (Courtesy of Arizona Rangers Museum and Archives.)

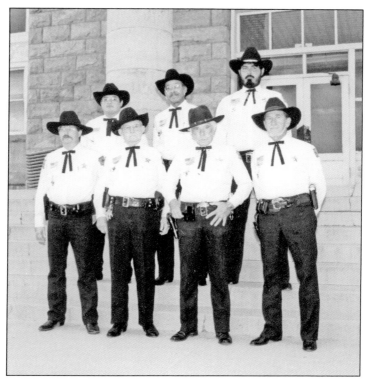

An Arizona Ranger demonstrates proper handcuffing technique during a company training session. (Courtesy of Arizona Rangers Museum and Archives.)

Mounted Rangers from Canoa Company perform duties at a Cinco De Mayo festival. (Courtesy of Arizona Rangers Museum and Archives.)

Rangers discuss their history while exhibiting historical artifacts at a shopping mall. As per their stated mission goals, the Rangers give public displays, presentations, and lectures to various audiences throughout the state to educate Arizonans about the contributions made since 1901. (Courtesy of Arizona Rangers Museum and Archives.)

At the 1993 Music Fest, Arizona Rangers meet with Roy Rogers. Rangers have interacted with numerous celebrities over the years, especially country-and-western singers. (Courtesy of Arizona Rangers Museum and Archives.)

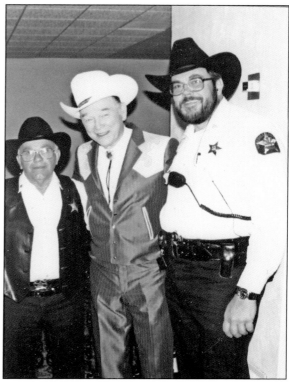

Tucson Company, pictured about 1993, has a long history of service to the community and state. (Courtesy of Arizona Rangers Museum and Archives.)

Arizona Rangers attend Citizens Academy, which is also open to all residents. Rangers generally enroll in any and all law enforcement–related courses made available to them, including some certified by Arizona POST (Peace Officer Standards and Training). (Courtesy of Arizona Rangers Museum and Archives.)

Suited up with safety vests and prepared to conduct traffic control for the 1996 Marana Founders Day Parade are Rangers Dave Bruce (left) and Joe Smelt. (Courtesy of Joanie Bruce.)

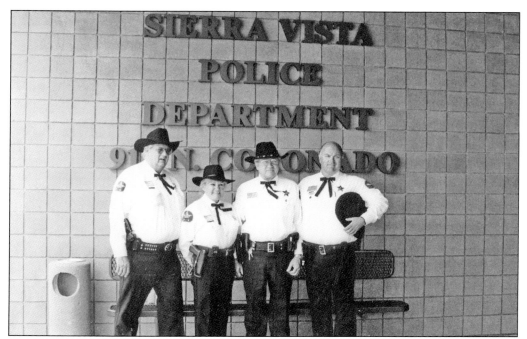

State commander Col. Sam Samsom (right) appears with his Ranger staff after making both the Sierra Vista mayor and chief of police honorary Arizona Rangers. (Courtesy of Joanie Bruce.)

Capt. Spud Hester, commander of Tucson Company, receives a Southern Arizona DUI Task Force Award in May 1997. At left is Arizona Department of Public Safety Task Force president Sgt. Ed Slechta, and at right is Governor's Office of Highway Safety representative Alberto Guiter. (Courtesy of Joanie Bruce.)

On October 6, 1997, Pima County attorney Barbara LaWall receives an honorary Arizona Rangers badge and gifts from Tucson Company commander Capt. Sam Samson and Capt. Fran Qurioz. (Courtesy of Lt. David Bruce.)

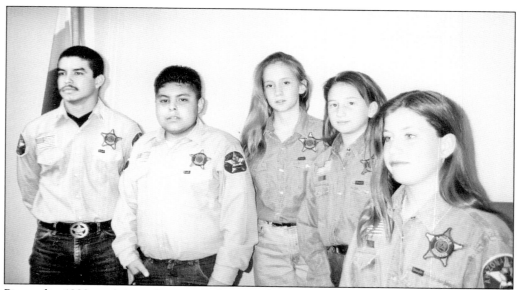

Pictured in 1998 are Arizona Rangers Cadets, members of a program sponsored by the organization to educate youth about citizenship, leadership, safety, and service to the community and its residents. (Courtesy of Arizona Rangers Museum and Archives.)

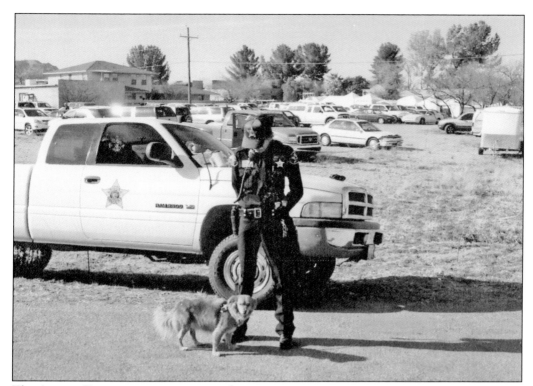

The Arizona Rangers even experimented with implementing a K-9 unit. Here Ranger James Beasley looks down on his faithful partner, Sporty. Note the badge on the dog's collar. (Courtesy of Lt. Col. Samuel Jones.)

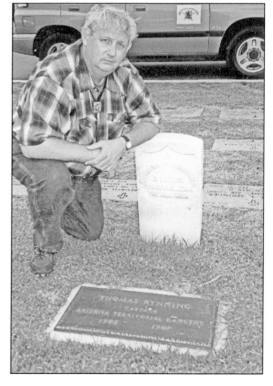

Off-duty Ranger Dave Bruce visits the grave site of Capt. Tom Rynning in 1998. Located at Rosecrans National Cemetery at Point Loma in San Diego, the government headstone denotes Rynning's status as a Rough Rider, with the plaque in the foreground indicating his service as an Arizona Rangers captain. (Courtesy of Joanie Bruce.)

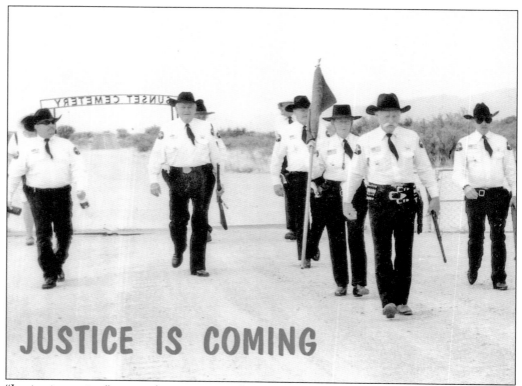

JUSTICE IS COMING

"Justice is coming," warns the caption on this photograph, which shows the Arizona Rangers honor guard at the grave site–marking memorial ceremony for Territorial Ranger Sgt. Oscar J. McAda (1907–1909). (Courtesy of Joanie Bruce.)

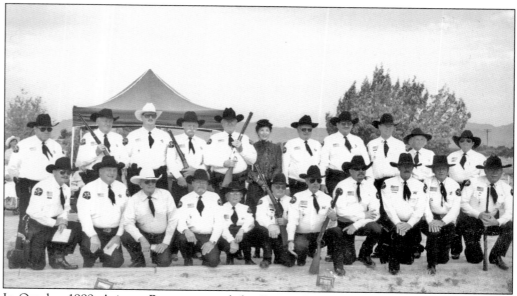

In October 1999, Arizona Rangers attend the Sunset Cemetery in Willcox for the grave site marking and memorial service for Sergeant McAda. (Courtesy of Joanie Bruce.)

Descendants of Sergeant McAda look at the newly marked headstone. (Courtesy of Joanie Bruce.)

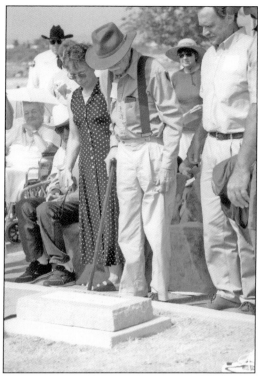

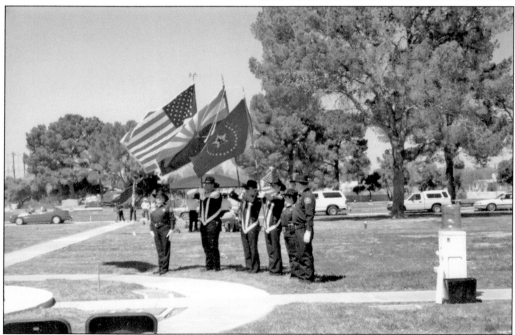

Arizona Rangers perform duties as a color guard at a public function. All companies perform these ceremonial duties throughout the year for numerous organizations, patriotic events, and holidays. (Courtesy of Maj. Anita Korhonen.)

At the office in 1999 are, from left to right, Sgt. Dave Bruce, Capt. Mike Dennis, Col. Rich Schloss, and Capt. Spud Hester. The occasion for the visit was to present Gov. Jane Dee Hull with a certificate and plaque designating her as Chief Ranger. (Courtesy of Joanie Bruce.)

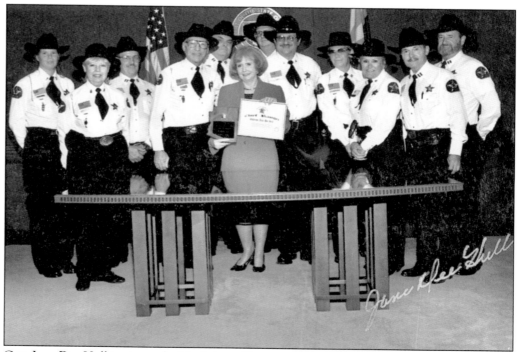

Gov. Jane Dee Hull is pictured with Arizona Rangers in October 1999 after having received her official certificate and plaque. (Courtesy of Joanie Bruce.)

Four

FEW BUT PROUD, THEN AND NOW
2000–2007

Met with both apprehension and hope, the year 2000 brought many additional challenges to the nation and to the Arizona Rangers. The organization continued to meet its four-point corporate purpose:

1. Render, when called upon by any Federal, State, County, or Local Law Enforcement Authority, such law enforcement assistance as may be required, and within the capabilities of the Arizona rangers, but only under the direction and supervision of such authority. 2. Provide support for those youth organizations and activities which contribute to the development of youth in matters of good morals and good citizenship. 3. Support activities which, in the judgment of the voting membership, are deemed to be of benefit to all parties involved. 4. Engage in activities which tend to keep alive the traditions of the Old West.

The year 2001 was celebrated by legislative proclamation as the "Centennial Year of the Arizona Rangers"; unfortunately, it was not long celebrated because of the events of September 11, 2001, when the United States was attacked and plunged into a new era of the War on Terror. *Homeland security* became buzzwords, and the federal government established a department to address the issue.

The Arizona Rangers suddenly had a renewed sense of mission and purpose, as communities and border towns became potential targets for terrorists and criminal elements. They further advanced their professionalism and training to meet the challenge. Numerous Rangers—both past and present—are regular, reserve, retired, or former peace officers and contribute to the professional education and training of the organization. Now a potential recruit must undergo a thorough background investigation, qualify for an Arizona firearms concealed carry permit, and successfully pass an oral interview before being considered for probationary Ranger status. The Arizona Rangers Training Academy must then be completed to surpass the probationary level. Today the Arizona Rangers have endured and overcome a number of legislative obstacles and continue to stand tall as they protect and serve the citizenry of Arizona. Anyone interested in becoming an Arizona Ranger or just learning more about this fine organization should visit the Web site www.azrangers.us, which lists contacts for all Ranger companies.

Arizona Rangers and veterans help guard the traveling Vietnam Memorial Wall in Tucson in 2000. (Courtesy of Maj. Anita Korhonen.)

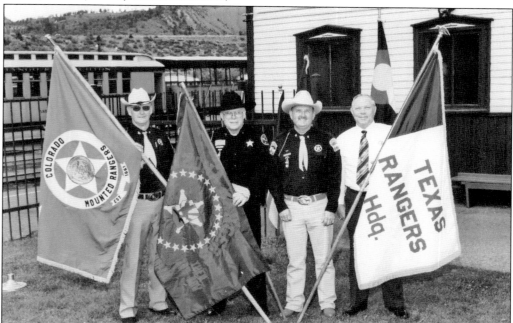

On October 7, 2000, the three foremost Ranger organizations in the United States met for the first time in Durango, Colorado. Representatives of the Texas Rangers, Colorado Mounted Rangers, and Arizona Rangers came together to discuss their associations, histories, and missions. (Courtesy of Arizona Rangers Museum and Archives.)

In February 2001, Arizona Rangers, along with an Arizona Department of Public Safety lieutenant, appeared at the state capitol to testify before a legislative committee on proposed Arizona Rangers legislation. (Courtesy of Joanie Bruce.)

Arizona Rangers are pictured with retired army reserve colonel and state representative Phil Hanson (right) in March 2001. Representative Hanson sponsored House Concurrent Resolution No. 2016 to honor the Arizona Rangers for their service to the state of Arizona. He was subsequently made an honorary Arizona Ranger colonel and frequently participates in their activities and training. (Courtesy of Joanie Bruce.)

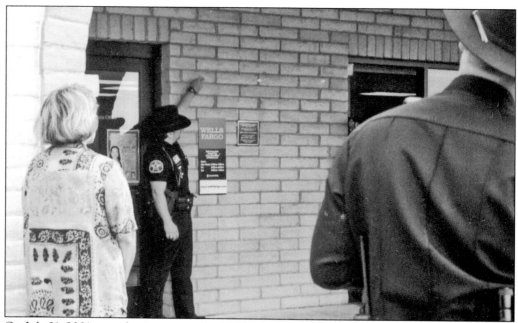

On July 21, 2001, exactly nine years after his death, Sgt. John W. Thomas was memorialized with a ceremony and a plaque placed on the outside wall of the Sierra Vista branch of Wells Fargo Bank. (Courtesy of Ranger Charles Flynt.)

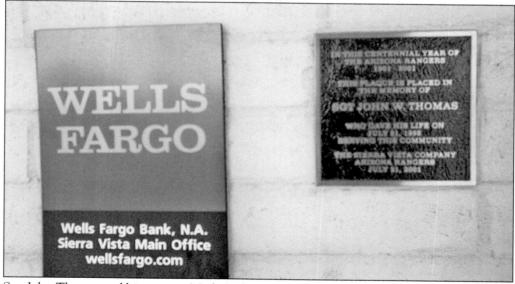

Sgt. John Thomas and his partner, Mark A. Genz, were performing duties as uniformed Arizona Rangers at a community function. They went to the bank to deposit some proceeds and found they had happened onto an ATM robbery in progress. When the Rangers confronted the suspect, he immediately started shooting at Sergeant Thomas. Thomas collapsed and Genz returned fire, hitting the suspect in the leg. The robber then fled the scene. Sergeant Thomas had sustained two gunshot wounds to the head and one to the wrist. Although rushed to a hospital, he died as a result of these wounds. The suspect was ultimately arrested and convicted. (Courtesy of author.)

Arizona Rangers attend the memorial plaque ceremony for Sgt. John Thomas. (Courtesy of Ranger Charles Flynt.)

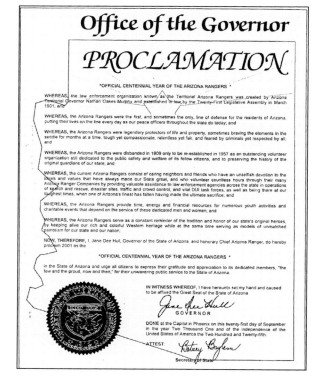

This Office of the Governor proclamation, signed by Gov. Jane Dee Hull on September 21, 2001, designated 2001 as the "Official Centennial Year of the Arizona Rangers." (Courtesy of Arizona Rangers Museum and Archives.)

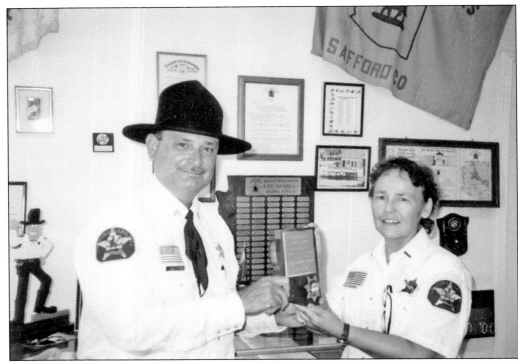

Arizona Rangers historian and museum curator Lt. Anita Korhonen receives a donation from Sgt. Bob Buie in 2001. (Courtesy of Maj. Anita Korhonen.)

Former Arizona Ranger Troit Stowe (center), a newly commissioned deputy sheriff with Pinal County, is shown upon his graduation from the Central Arizona Law Enforcement Training Academy in Casa Grande on April 19, 2002. Many Rangers go on to pursue law enforcement careers. At left is Sgt. Dave Bruce, and at right is Lt. Charles Flynt. (Courtesy of Joanie Bruce.)

After passing their probationary period, Coronado Company Rangers receive their charter as a certified company. (Courtesy of Arizona Rangers Museum and Archives.)

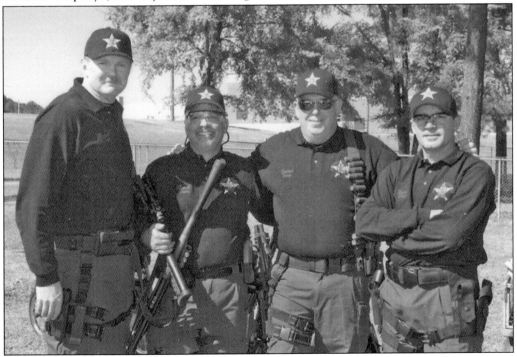

The Arizona Rangers also have a SWAT team that has done extremely well in national-level competitions. Pictured from left to right are Phil Jensen, Hank Diaz, Robert Smith, and Bill Lionberger. The occasion for this photograph was their participation in the Third Annual Three Gun Competition in Fayetteville, North Carolina. The Arizona Rangers SWAT Competition Team also competed at the 2002 World Three Gun Championship match held in Las Vegas, Nevada, taking second place in the law enforcement category. (Courtesy of Capt. Jane Smith.)

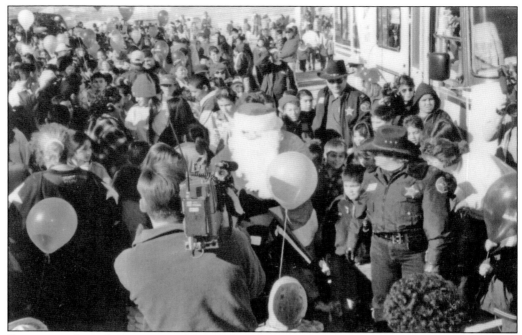

Rangers perform duties among the crowd at the annual Miracle on 34th Street charity. This event is conducted every Christmas Eve for needy children and low-income families. (Courtesy of Lt. Carol Sullivan.)

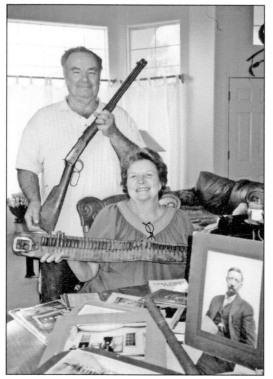

Mildred Eaves, seen in her home with her husband, displays equipment, photographs, and memorabilia belonging to her grandfather Pvt. Robert M. Anderson. Arizona Rangers historians and other researchers are often in contact with the descendants of the Territorial Rangers. Private Anderson's grave site, located in Globe, was subsequently marked and honored on November 10, 2002. (Courtesy of Maj. Anita Korhonen.)

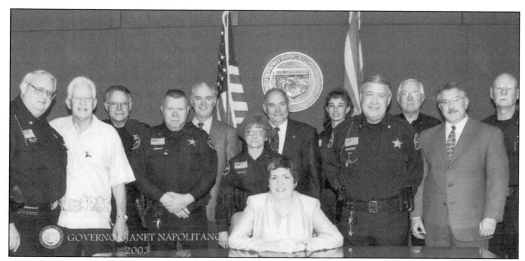

Gov. Janet Napolitano poses with the Arizona Rangers Board of Directors and four state officials in 2003. (Courtesy of Arizona Rangers Museum and Archives.)

On July 2, 2003, Gov. Janet Napolitano receives a plaque and badge with her credential as Chief Ranger from state law enforcement support coordinator Sgt. Dave Bruce. In 2007, while addressing proposed militia legislation, Governor Napolitano was heard to say words to this effect: "We already have a militia; they're called the Arizona Rangers." (Courtesy of Joanie Bruce.)

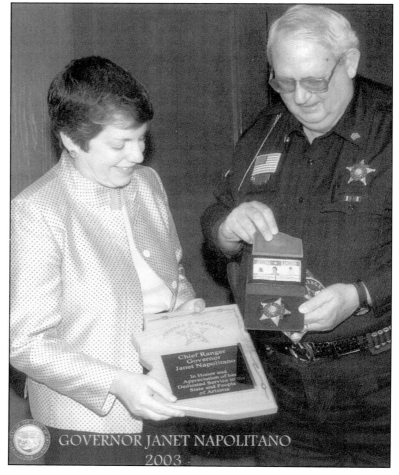

Arizona Rangers serve alongside Pima College Police during a college football game in 2003. These types of duties are performed statewide among the various companies. (Courtesy of Joanie Bruce.)

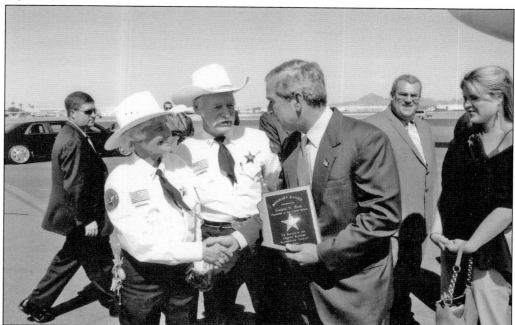

On October 12, 2004, while visiting Arizona, Pres. George W. Bush was made an honorary Arizona Ranger. Here Superstition Company commander Capt. Rowe Gilbert and his wife, Lt. Barbara Gilbert, present the plaque to President Bush at the Sky Harbor International Airport in Phoenix. (Courtesy of Maj. Anita Korhonen.)

On December 4, 2004, Sr. Sgt. Ed Slechta (center) became the first active-duty member of the Arizona Department of Public Safety to be made an honorary Arizona Ranger. At left is Maj. Spud Hester, and at right is Lt. Dave Bruce. (Courtesy of Joanie Bruce.)

Arizona Rangers from Tucson Company participate in the Shop with a Cop program alongside Tucson police officers in December 2004. The program is designed to bring Christmas cheer to needy children and low-income families. (Courtesy of Joanie Bruce.)

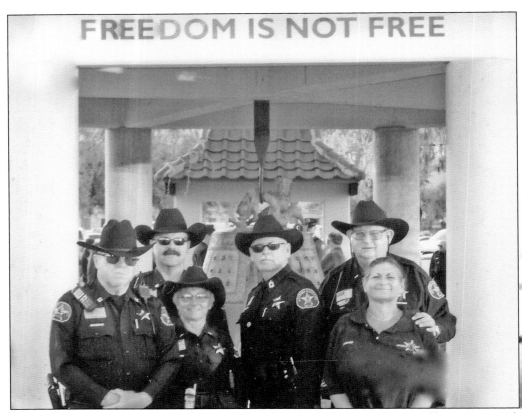

Every year, Arizona Rangers participate in festivities at the Arizona Peace Officers Memorial, located on the Phoenix Capital Mall. (Courtesy of Lt. David Bruce.)

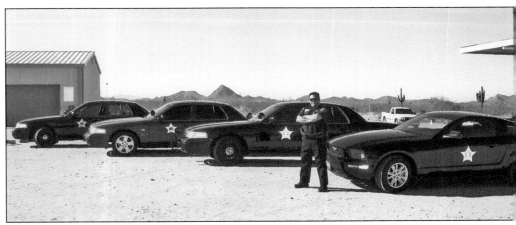

Shown here is the Phoenix Company motor pool fleet of marked vehicles. (Courtesy of Phoenix Company.)

Arizona Ranger Anthony Vann performs a close-quarters battle, live-fire technique on a silhouette target at the Ben Avery Shooting Facility in Phoenix. (Courtesy of Ranger Anthony Vann.)

Second-generation Arizona Ranger Vern Lewis follows up the close-quarters battle, live-fire shooting technique on a silhouette target at the Ben Avery Shooting Facility in Phoenix. (Courtesy of Ranger Anthony Vann.)

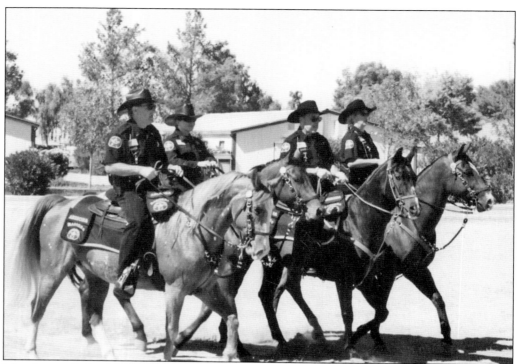

Members of the Verde Valley Mounted Patrol Unit strut their stuff. (Courtesy of Maj. Anita Korhonen.)

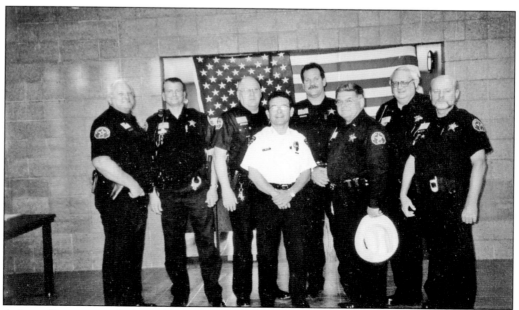

Arizona Rangers regularly graduate from the Tucson Police Citizens Academy. Seen in the white shirt is Tucson chief of police Richard Miranda. (Courtesy of Joanie Bruce.)

Ranger Carl Lawrence performs crossing-guard duty at an elementary school in Sierra Vista. When concerns were expressed about unsafe traffic at the school, Sierra Vista Company Rangers stepped up to provide a uniformed presence. (Courtesy of Maj. Carl Lawrence.)

Ranger Charles Flynt directs traffic during a bicycle race. The various Ranger companies are very active in providing such service to their communities. (Courtesy of Ranger Charles Flynt.)

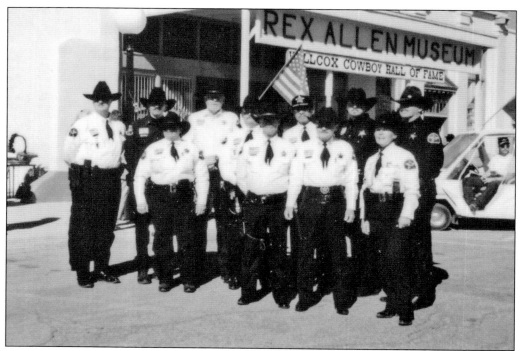

Here Rangers stand in front of the Rex Allen Museum and Cowboy Hall of Fame. The organization regularly participates in Willcox's annual Rex Allen Days celebration held every October. Mounted Rangers walk in the parade while others maintain security and perform crowd and traffic control. (Courtesy of Arizona Rangers Museum and Archives.)

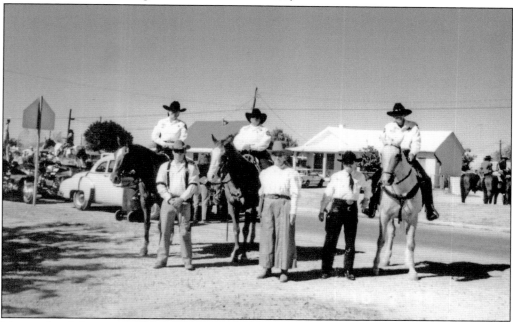

Mounted and dismounted Rangers prepare to perform duties during Rex Allen Days in Willcox. (Courtesy of Arizona Rangers Museum and Archives.)

Rangers help local police during the Sun Riders Motorcycle Club's Christmas fund-raising ride. (Courtesy of Arizona Rangers Museum and Archives.)

On March 20, 2005, Arizona Rangers from Tucson Company participated in the 125th anniversary of the arrival of the first train to Tucson. The celebration took place at the Tucson railroad depot, with about 200 folks dressed in period attire and numerous government officials in attendance. The Rangers had been requested to provide a presence for the occasion; nine Rangers volunteered for the security duty. (Courtesy of Joanie Bruce.)

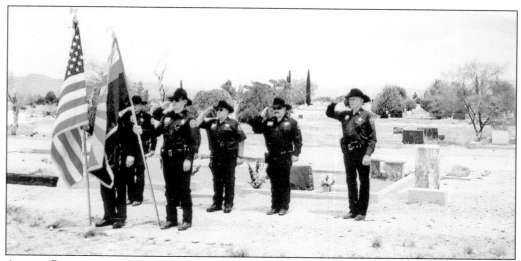

Arizona Rangers attend the Safford grave site memorial marking ceremony for Territorial Ranger Sgt. Henry S. Gray on May 4, 2005. Sergeant Gray was born in California and enlisted at age 47. He served at the Morenci mining strike in 1903, and an arrestee subsequently made accusations against Gray. Charges were filed in 1904. The case was adjudicated after a number of appearances in Tucson. (Courtesy of Joanie Bruce.)

Seen at left on July 18, 2005, is famous Old West historian, writer, and honorary Arizona Ranger Bill O'Neal. This photograph was taken after he delivered a presentation for the Tucson Company. O'Neal is the author of numerous articles and books about the Old West, with two on the subjects of the Arizona Rangers and Capt. Harry Wheeler. Please refer to the bibliography for more information. (Courtesy of Joanie Bruce.)

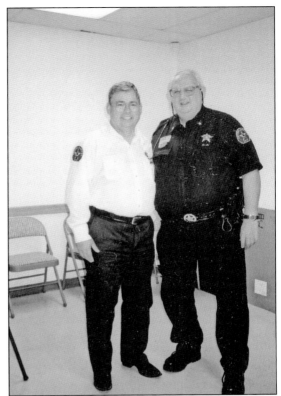

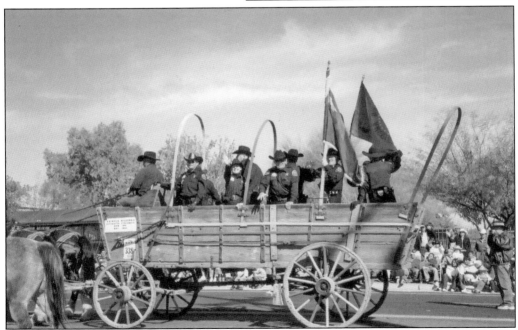

Tucson Company Rangers participate in the 2006 Tucson Rodeo Parade. (Courtesy of Joanie Bruce.)

Official Arizona state historian and honorary Arizona Ranger Marshall Trimble (left), associate Joanie Bruce (center), and Lt. Dave Bruce are seen at the John Slaughter Ranch on July 18, 2006. They are attending the first Douglas Company–hosted annual cookout and picnic. (Courtesy of Lt. David Bruce.)

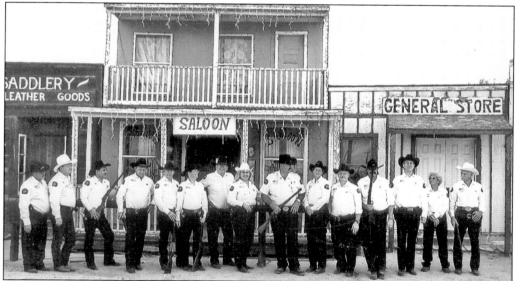

Currently 14 companies of Arizona Rangers are located throughout the state. All companies perform those duties that are identified in the organizational bylaws. However, some specialize in additional activities such as Superstition Company, headquartered in Florence. In addition to their primary duties, members perform historical Wild West gunfights and reenactments at various public and private functions. Owning double-buscalero gun-belt rigs and single-action revolvers are all the rage in this outfit. (Courtesy of Capt. Rowe Gilbert.)

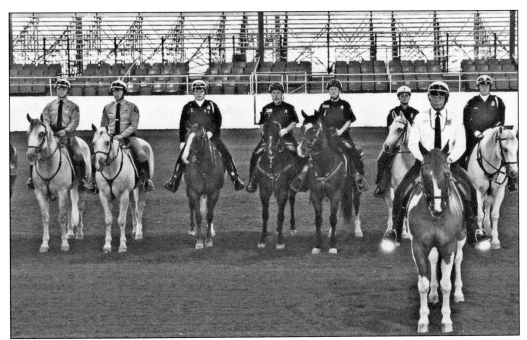

Rangers from Verde Valley Company, along with Arizona peace officers from various agencies, participate in an Arizona POST-certified mounted patrol course. The training was conducted at West World in Scottsdale by Geiser Mounted Training. (Courtesy of Capt. Dee Zenk.)

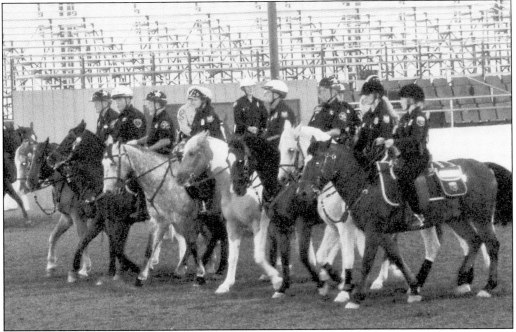

Pictured here is another mounted patrol class attended by Rangers from Verde Valley Company. Verde Valley's Mounted Unit was the first to be fully certified in the Arizona Rangers. (Courtesy of Capt. Dee Zenk.)

Verde Valley Company provides volunteer, non-salaried security for the annual fund-raising community event Taste of Sedona. Rangers Mahlon Ramsey (left), Capt. Dee Zenk (center), and Patrick Farley are shown in this photograph. (Courtesy of Capt. Dee Zenk.)

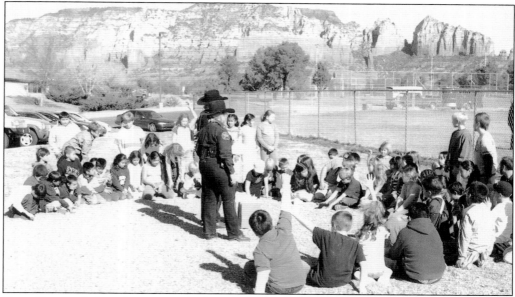

Capt. Dee Zenk (standing center background), the commander of the Verde Valley Company, and Lt. Karen Livesay (standing center foreground) take part in the national Character Counts education program at West Sedona Elementary School in December 2006. The fourth-grade students are taught over a period of seven weeks about respect, responsibility, trustworthiness, caring, and citizenship. For more than five years, Verde Valley Rangers have conducted mounted patrol demonstrations as part of the program. (Courtesy of Capt. Dee Zenk.)

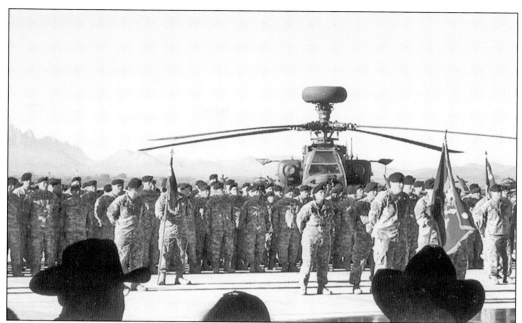

On January 2, 2007, Arizona Rangers look on as personnel of the Arizona Army National Guard 1st Battalion, 285th Aviation Regiment, conduct their certification and deployment ceremony in Marana. They were subsequently deployed to Afghanistan. (Courtesy of Terri Dodge.)

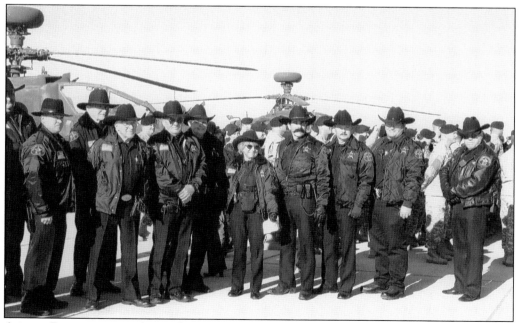

Arizona Rangers pose in front of one of the aircraft. The men and women of the 1st Battalion, 285th Aviation Regiment, were made honorary Arizona Rangers and authorized to use the logo on their aircraft. (Courtesy of Terri Dodge.)

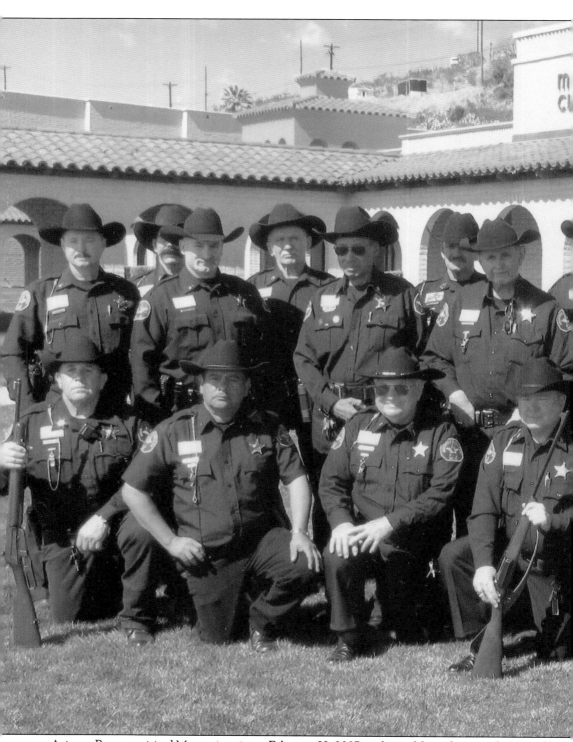

Arizona Rangers visited Morenci again on February 22, 2007, and posed for a photograph. Hosted by the Phelps Dodge Mining Company and given the royal treatment, the Rangers reciprocated with the

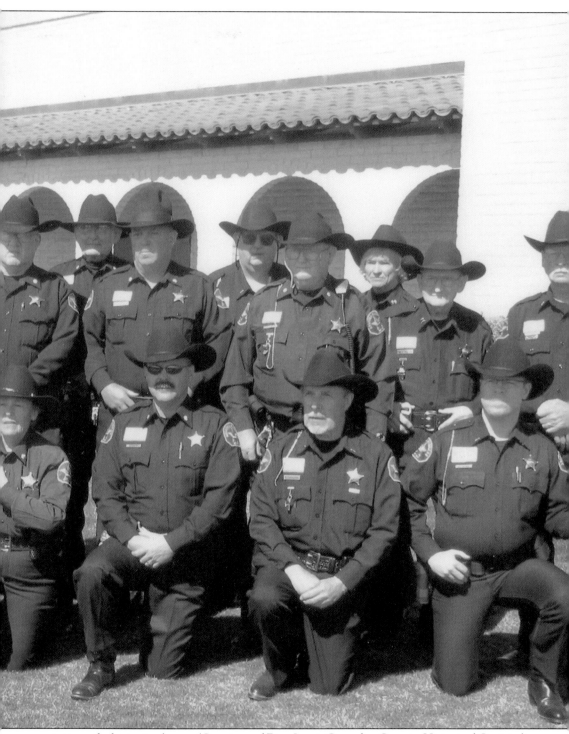

presentation of a historic plaque. (Courtesy of Don Lunt, Greenlee County Historical Society.)

Training with firearms is an ongoing process: Rangers are required to qualify regularly with "meets standards" performance and shooting scores. The shooting program is diverse, and Rangers are provided with various scenarios and challenges. The instructors are certified to teach firearms as well as other use-of-force options. (Courtesy of Capt. Dee Zenk.)

Ranger Karen Livesay of Verde Valley Company shoots the qualification course from behind a barrier. (Courtesy of Capt. Dee Zenk.)

Ranger Amy Grace Hauschild of Verde Valley Company shoots the qualification course from behind a barrier. (Courtesy of Capt. Dee Zenk.)

Pictured here is some Rangers humor, with M.Sgt. Phil Jenson at left and "old dude" Maj. Robert Smith at right. (Courtesy of Capt. Dee Zenk.)

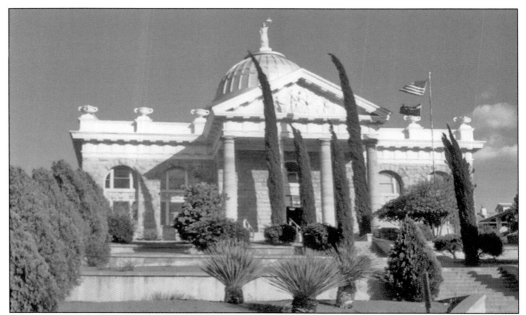

The 1904 Santa Cruz County Territorial Courthouse, located in Nogales, now hosts the Arizona Rangers Museum, along with other community organizations. In its day, it served as the county jail, where numerous arrestees were housed, and the court, where they were tried. Just as they do today, Arizona Rangers made appearances and gave sworn testimony. (Courtesy of author.)

The modest Arizona Rangers Museum, which reopened on March 23, 2007, after remodeling, provides an impressive display of artifacts, documents, and archives for public researchers. Arizona Rangers are very hospitable while performing duties as docents who guide and answer visitors' questions. The museum is open most Saturdays or by appointment and is well worth the visit by anyone interested in learning more about the organization's colorful history. (Courtesy of author.)

The Arizona Rangers Museum interior includes numerous displays about the organization's history. (Courtesy of author.)

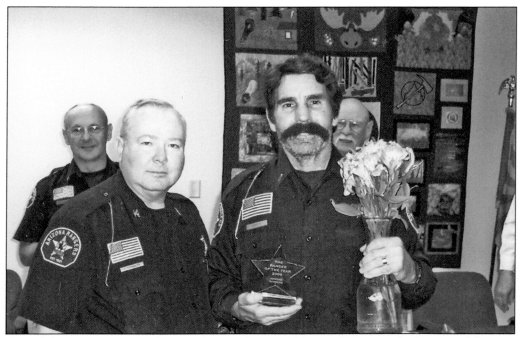

One of the most prestigious honors that can be earned by any Ranger is the Ranger of the Year Award, given annually for exceptional service. Here state commander Col. Sid Chandler (left) presents the 2006 award to Lt. Kenn Barrett at the quarterly meeting in Rio Rico on March 24, 2007. (Courtesy of author.)

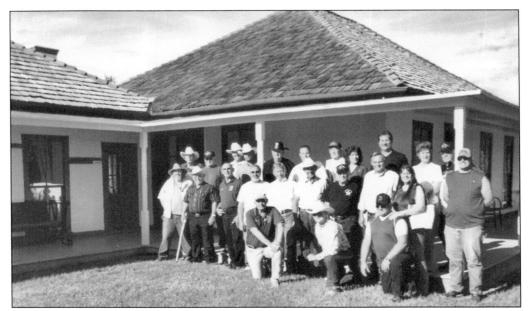

Off-duty Rangers participate in the Douglas Company–sponsored Second Annual Spring Cookout and Family Picnic, held at the John Slaughter Ranch on April 29, 2007. For the last 14 years, the ranch managers have been Ranger John Levanchy and his wife, Norma. Sheriff Slaughter would be proud to know that Arizona Rangers are looking after his ranch and continuing to visit just like in the old days. (Courtesy of author.)

Maj. Ty Mayer demonstrates a baton defensive technique. Arizona Rangers receive baton certification training from instructors of the Arizona Ranger Training Academy. Rangers are certified in most of the use-of-force levels that are required of regular peace officers. Training academy courses are provided throughout the state to facilitate attendance. (Courtesy of author.)

In these two photographs, Arizona Rangers are undergoing baton certification training. (Courtesy of author.)

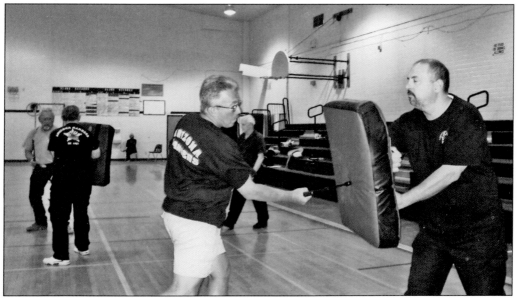

Capt. Mike Gerard (left), the commander of Sierra Vista Company, congratulates and thanks Rangers chaplain John Van Arsdel for his many years of service. Chaplain emeritus Van Arsdel first joined the Arizona Rangers in 1959. Note the Transportation Safety Administration uniform worn by Captain Gerard. (Courtesy of author.)

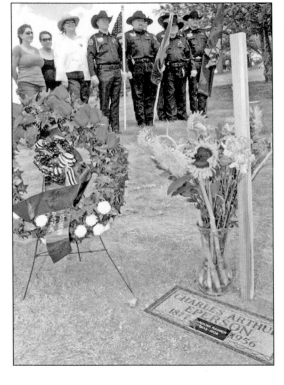

On September 9, 2007, a grave-marking ceremony was conducted for Pvt. Charles A. Eperson. Three generations of his female descendants were in attendance, along with functionaries and honor guard. Unfortunately some of the graves remain unmarked and may never be identified, but the Arizona Rangers will continue to mark those of the original Territorial Rangers as they are located. (Courtesy of Maj. Anita Korhonen.)

Five

ARIZONA RANGERS POTPOURRI

Much has been made of the Arizona Rangers legend in motion pictures, television, literature, and music. Some of the early films included the titles *Arizona Legion* (1939), starring George O'Brien; *The Arizona Ranger* (1948), starring Tim Holt; *Arizona Raiders* (1965), starring Audie Murphy; and *The Last Hard Men* (1976), starring Charlton Heston. Of course, the television series *26 Men* (1958), which starred Tris Coffin as Capt. Tom Rynning, was also a favorite.

Currently there is sketchy information about a motion picture in the works titled *Arizona Rangers*, with the soundtrack already having been released. Numerous articles and books—both historically factual and fictional—have been written about Rangers' adventures. In the music category are the theme song for the *26 Men* television series and Marty Robbins's renowned "Big Iron." A number of historic Web sites are devoted to Rangers and host exhibits. Today reenactors portray Arizona Rangers in gunfights, plays, and shooting matches and perform living history demonstrations. It appears that the Arizona Rangers legend will endure as long as this country remains a nation of free citizens.

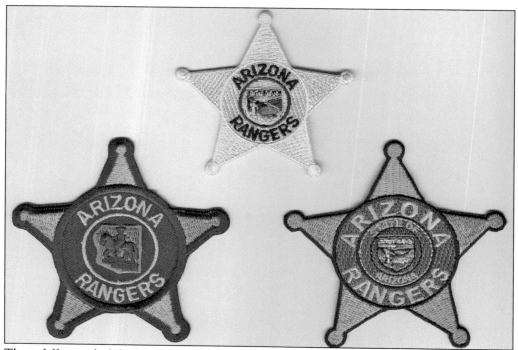

Three different cloth badges are used on various Rangers uniforms and jackets. The badge in the upper center is authorized for uniform wear. (Courtesy of Ranger Charles Flynt.)

Shown here is the evolution of the Arizona Rangers shoulder patches. In the lower right is the current-issue patch. (Courtesy of author.)

The Arizona Rangers of today are authorized to wear these three Western-style buckles with their uniforms. (Courtesy of author.)

Pictured here are a replica Arizona Territorial Rangers badge and a current-issue badge, along with both obsolete and current identification cards. (Courtesy of Maj. Dennis C. Harrington.)

These badges and identification cards were used by Maj. Dennis C. Harrington over the years. Like that of many other Rangers, Harrington's selection includes special commissions with local agencies. (Courtesy of Maj. Dennis C. Harrington.)

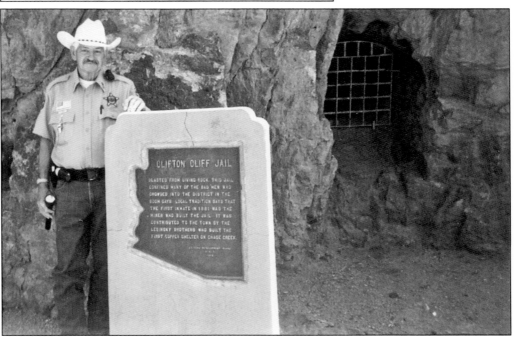

Ranger Bill Inman is seen at the Clifton Cliff Jail. The jail consists of two levels, with the actual cells situated in a subterranean cave with dirt floors and strap-iron cell hardware. In all probability, Rangers used this jail to confine arrestees. (Courtesy of author.)

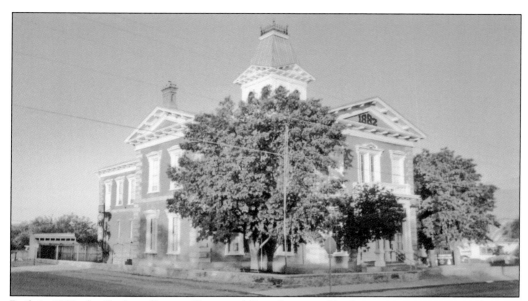

Built in 1882, the Cochise County Territorial Courthouse in Tombstone now serves as an Arizona State Historic Park. In its day, many Arizona Rangers arrestees were jailed, tried, and sentenced here. After the Rangers were legislated out of existence, Capt. Harry Wheeler performed his duties here as both a deputy and a sheriff. The must-see location gives the visitor the feeling of what frontier law enforcement and judicial proceedings were really like. It includes a modest Arizona Rangers exhibit, along with numerous law-and-order and local history displays. (Courtesy of author.)

Yuma Territorial Prison, opened in southwest Arizona in 1876, also operates today as an Arizona State Historic Park. Yuma was considered one of the most notorious prisons where an outlaw could be sentenced, earning the nickname "Hell Hole." Arizona Rangers made significant contributions to its guest list, and the last superintendent was Capt. Tom Rynning. It is a must-see site for anyone interested in the Old West. (Courtesy of author.)

Undoubtedly Arizona Rangers hooked and booked many an outlaw at the Bisbee jail, built in 1904. Today it serves as a residence. (Courtesy of author.)

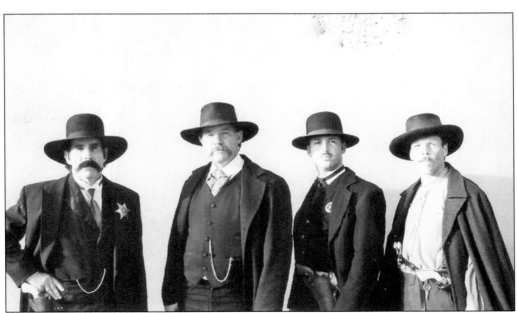

Lt. Kenn Barrett (left, playing Virgil Earp) participates in a professional acting group that performs regularly in Tombstone. He is pictured here with, from left to right, Wyatt Earp, Morgan Earp, and Doc Holliday. Lieutenant Barrett established and directed the first Capt. Harry C. Wheeler Memorial Shooting Match, held on October 7, 2007, at Tombstone. (Courtesy of Lt. Kenn Barrett.)

Old Tucson Studios also gets in on the Arizona Rangers act with its outdoor action drama *The Raid on Phillips Ranch*. Note the heroic Ranger in the center, who takes quite a beating before prevailing against evil. (Courtesy of author.)

Arizona Rangers are also popular among reenactors and living history enthusiasts in Europe. These people, from the Netherlands Living History Group 1860–1909 Europe, portray all the Arizona Rangers periods, including the Confederacy. Rangers reenactors perform in the United Kingdom and Germany as well. (Courtesy of Netherlands Living History Group 1860–1909 Europe.)

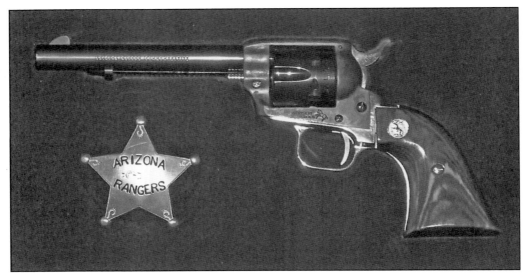

In 1972, Colt Firearms introduced the Arizona Ranger commemorative revolver. Designed the same as the single-action army model, it is the smaller-framed Scout model version in .22 caliber. A handsome piece, the revolver is made of blue steel with nickel accents and rosewood stocks. It was issued with a replica Arizona Rangers badge in a presentation walnut box. (Courtesy of author.)

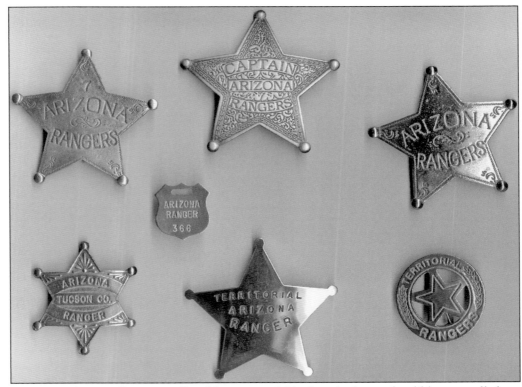

Numerous Arizona Rangers collectibles are available, but the buyer should beware; all these examples lack authenticity or provenance. (Courtesy of author.)

The Arizona Territorial Rangers, also known as "Waddies," are shown here during the 2007 Winter Range. The event, billed as the Single Action Shooting Society National Championship of Cowboy Action Shooting, is held annually at the Ben Avery Shooting Facility in Phoenix and hosted by the Arizona Territorial Company of Rough Riders. (Courtesy of Major Photography.)

This trophy of an Arizona Ranger was designed and sculpted by Rick Merrill for the first-place winner of each category in the Winter Range Cowboy Action Shooting Championship. Later, when Ruger Firearms became the match sponsor, the company required that the hand over the carbine muzzle be repositioned. (Courtesy of Larry Nelson.)

These "top 10" trophy buckles are awarded to Winter Range shooting contestants who place 1st through 10th in their respective categories. Note the Morenci Arizona Rangers lineup design minus the Winchesters. (Courtesy of Arizona Territorial Company of Rough Riders.)

A parting shot shows the author participating as an Arizona Territorial Ranger at the 2007 Winter Range. With the alias of "Deputy Deuce," the author is active in cowboy action shooting, just like many Arizona Rangers. A retired peace officer and army reserve captain with combat service in Vietnam, he has a bachelor of arts degree in history. This book is his second title in the Images of America series. (Courtesy of author.)

SELECTED BIBLIOGRAPHY

Adams, Ramon F. *Six-Guns and Saddle Leather.* Mineola, NY: Dover Publications, 1998.

Alexander, Bob. *Fearless Dave Allison: Border Lawman.* Silver City, NM: High-Lonesome Books, 2003.

Bailey, Lynn R. and Don Chaput. *Cochise County Stalwarts.* Vols. 1 and 2. Tucson, AZ: Westernlore Press, 2000.

Chaput, Don. *The Odyssey of Burt Alvord.* Tucson, AZ: Westernlore Press, 2000.

DeArment, Robert K. *Deadly Dozen: Twelve Forgotten Gunfighters of the Old West.* Norman, OK: University of Oklahoma Press, 2003.

Erwin, Allen A. *The Southwest of John Horton Slaughter.* Spokane, WA: Arthur H. Clark Company, 1965.

Feess, Marty F. *Theodore Roosevelt's Arizona Boys.* Lincoln, NE: Writers Club Press, 2001.

Hunt, Frazier. *Cap Mossman: Last of the Great Cowmen.* New York: Hastings House Publishers, 1951.

McFall, Larry L. *Why? Arizona Rangers.* Tombstone, AZ: Riodosa 40, 1996.

Meed, Douglas V. *Bloody Border.* Tucson, AZ: Westernlore Press, 1992.

Miller, Joseph. *The Arizona Rangers.* New York: Hastings House Publishers, 1972.

Nash, Jay R. *Encyclopedia of Western Lawmen and Outlaws.* New York, NY: Da Capo Press, Inc., 1989.

O'Neal, Bill. *The Arizona Rangers.* Austin, TX: Eakin Press, 1987.

———. *Captain Harry Wheeler: Arizona Lawman.* Austin, TX: Eakin Press, 2003.

Patterson, Richard. *Historical Atlas of the Old West.* Boulder, CO: Johnson Publishing Company, 1985.

Roosevelt, Theodore. *The Rough Riders.* New York, NY: Da Capo Press Inc., 1990.

Rynning, Captain Thomas H. *Gun Notches.* New York, NY: Frederick A. Stokes Company, 1931.

Trimble, Marshall, *Arizona Adventure.* Phoenix, AZ: Golden West Publishers, 1988.

———. *Arizoniana.* Phoenix, AZ: Golden West Publishers, 1988.

———. *In Old Arizona.* Phoenix, AZ: Golden West Publishers, 1985.

———. *The Law of the Gun.* Phoenix, AZ: Arizona Highways, 1997.

Virgines, George E. *Badges of Law and Order.* Rapid City, SD: Cochran Publishing, 1987.

DISCOVER THOUSANDS OF LOCAL HISTORY BOOKS FEATURING MILLIONS OF VINTAGE IMAGES

Arcadia Publishing, the leading local history publisher in the United States, is committed to making history accessible and meaningful through publishing books that celebrate and preserve the heritage of America's people and places.

Find more books like this at
www.arcadiapublishing.com

Search for your hometown history, your old stomping grounds, and even your favorite sports team.